painting with water-soluble oils

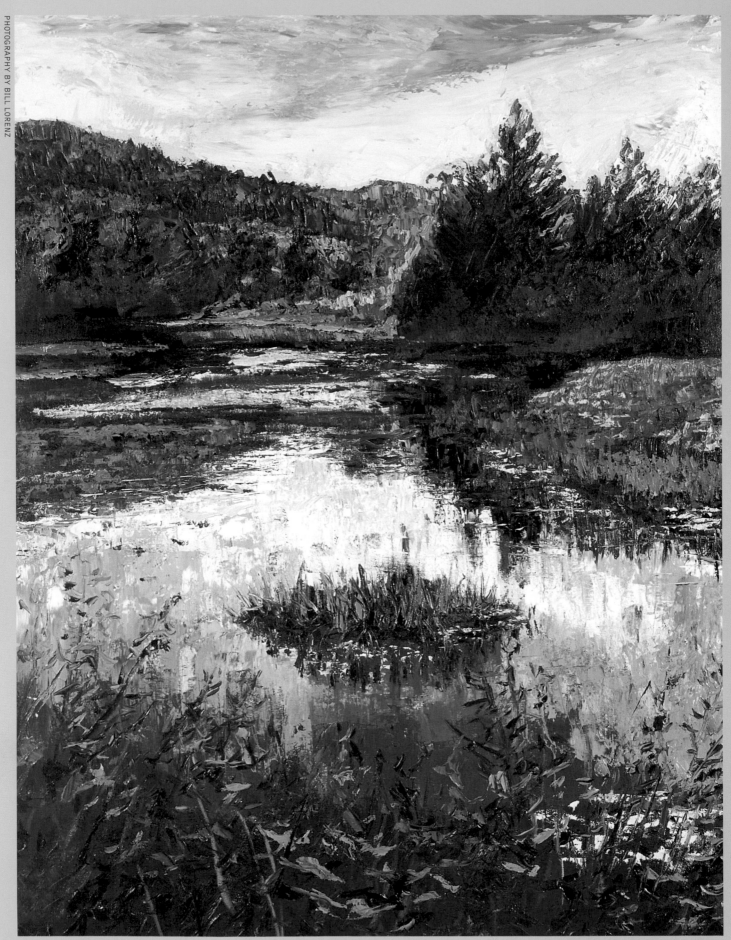

Pond at Leary Road • Sean Dye • Water-soluble oil on canvas • 48" × 36" (122cm × 91cm) • Collection of Paula Gren and Mark Winer

PAINTING WITH

Water Soluble Oils

Sean Dye

NORTH LIGHT BOOKS
CINCINNATI, OHIO
www.artistsnetwork.com

dedication

I would like to dedicate this book to my wife, Sally. She has stood by me throughout my entire career as an artist and supported me in every way. She is also my most honest critic.

To see more artwork by Sean Dye, please visit his website at www.seandyestudio.com.

Painting With Water-Soluble Oils. Copyright © 2001 by Sean Dye. Manufactured in China. All rights reserved. No part of this book may be reproduced in any form or by any electronic or mechanical means including information storage and retrieval systems without permission in writing from the publisher, except by a reviewer, who may quote brief passages in a review. Published by North Light Books, an imprint of F&W Publications, Inc., 1507 Dana Avenue, Cincinnati, Ohio 45207. (800) 289-0963. First edition.

Other fine North Light Books are available from your local bookstore, art supply store or direct from the publisher.

05 04 03 02 5 4 3 2

Library of Congress Cataloging-in-Publication Data

Dye, Sean, 1963-
 Painting with water-soluble oils / Sean Dye. — 1st ed.
 p. cm.
 Includes bibliographical references and index.
 ISBN 1-58180-033-9 (hc.)
 1. Painting—Technique. 2. Water-soluble oil paint. I. Title.
ND1533 .D97 2001 00-049618
751.45—dc21 CIP

Edited by James Markle, Marilyn Daiker and Stefanie Laufersweiler
Cover designed by Amber Traven
Interior designed by Wendy Dunning
Interior production art by Kathy Gardner
Production coordinated by John Peavler

metric conversion chart

to convert	to	multiply by
Inches	Centimeters	2.54
Centimeters	Inches	0.4
Feet	Centimeters	30.5
Centimeters	Feet	0.03
Yards	Meters	0.9
Meters	Yards	1.1
Sq. Inches	Sq. Centimeters	6.45
Sq. Centimeters	Sq. Inches	0.16
Sq. Feet	Sq. Meters	0.09
Sq. Meters	Sq. Feet	10.8
Sq. Yards	Sq. Meters	0.8
Sq. Meters	Sq. Yards	1.2
Pounds	Kilograms	0.45
Kilograms	Pounds	2.2
Ounces	Grams	28.4
Grams	Ounces	0.04

acknowledgments

I would like to begin by thanking my parents, Joe and Betty Dye, for believing in me and not discouraging me to pursue my dream to become an artist. Thanks to Rachel Rubin Wolf of North Light Books for helping me develop this book. My editors Marilyn Daiker and James Markle should be thanked for their patience, understanding and expert advice throughout the writing of this book.

E. Peter Hopper of HK Holbein, George Stegmire of Grumbacher, Wendell Upchurch and Michel Ritz of Winsor & Newton and my good friend John Bates of Black Horse Art Supply provided technical and historical information. Testing materials for the artists were generously provided by Sanford Corporation (Grumbacher), Canson-Talens Inc. (Van Gogh), HK Holbein, and Winsor & Newton. Canvas for the artists was provided by Mr. Costa Apokatanidis of Apollon Inc.

Thank you to my two interns, Jim Wright and Katherine Clear, who I'm afraid did not exactly know what they were getting themselves into. I'm not sure I realized just how hard the contributing expert artists had worked until I had to catch up to them by completing all of my artwork. Thanks so much to Greg Albert, Don Bruner, Linda Bruner, Jeanette Chupack, Robert Huntoon, Caroline Jasper, Kevin Macpherson, Wanda Macpherson, Lynda Reeves McIntyre, Katharine Montstream, Ned Mueller, Reed Prescott III, George Teichmann and Robert Wee. Bill Lorenz's photography was timely, accurate and artistic as always.

A special thanks goes to my good friends the Hopper family—Peter, Frances, Douglas and especially my good friend Timothy. They have continually supported my artistic efforts in so many ways.

Finally, this book would not have been possible and nothing would get done in the studio without the unending support of my wife, Sally.

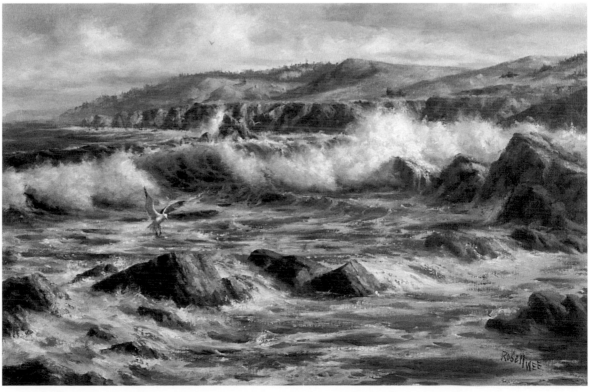

South of Big Sur · Robert Wee · Water-soluble oil on canvas · 20" X 30" (51cm X 76cm)

table of contents

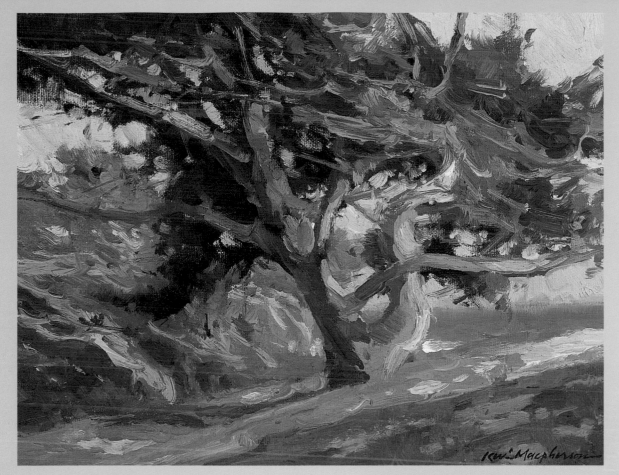

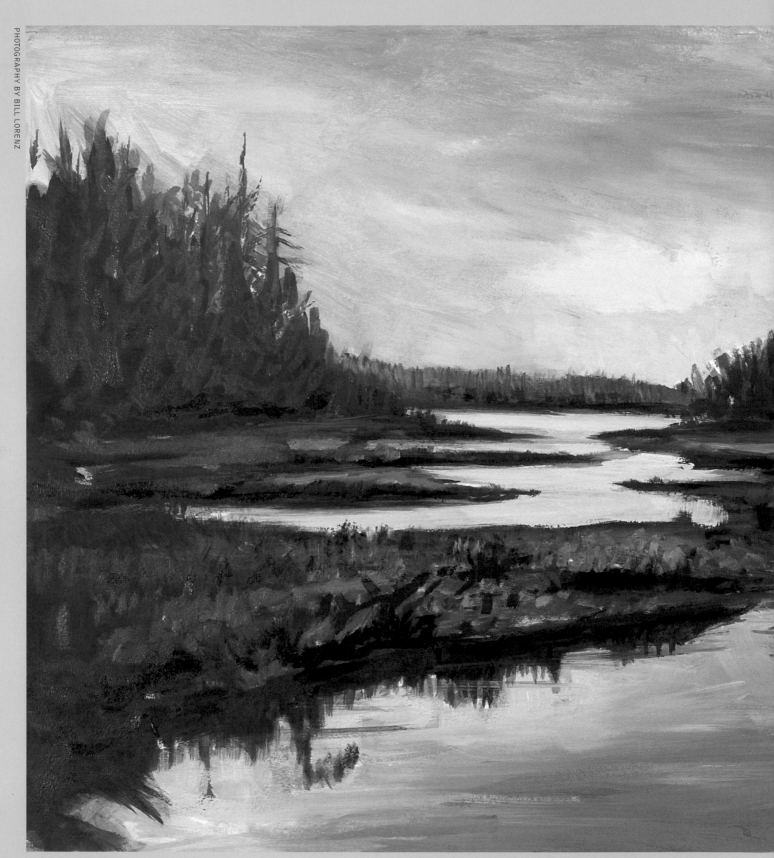

Entrance to Hogan Pond, Oxford, Maine • Sean Dye • Water-soluble oil on 140-lb. (300gsm) cold-pressed Imperial Paper • 22"×30" (56cm × 76cm) • Collection of the artist

introduction

I first heard of water-soluble oil color in the mid 1990s. I have to admit that like many other people I was skeptical. How could oil color be water-soluble? Could it truly be oil color? I thought oil and water didn't mix. Isn't that what we've learned since we were kids? Despite all of this uncertainty, I was intrigued. A self-described multimedia artist, I felt obliged to give this impossible new product some consideration. I acquired several sample tubes, bringing them back to my studio with every intention of trying them immediately. They sat for several months until one week when three different people asked my "professional" technical opinion on the new oils. I hurried to the studio and started to work. This book is a sort of documentary of my exploration of this incredible, revolutionary new art medium over the last year. The opinions, reactions and experiences of several other artists are represented here as well. The jury is back, and we have a verdict. I hope you too will soon be convinced of water-soluble oil color's tremendous value as a serious medium for today's artists. Read on—enjoy!

Sean Dye

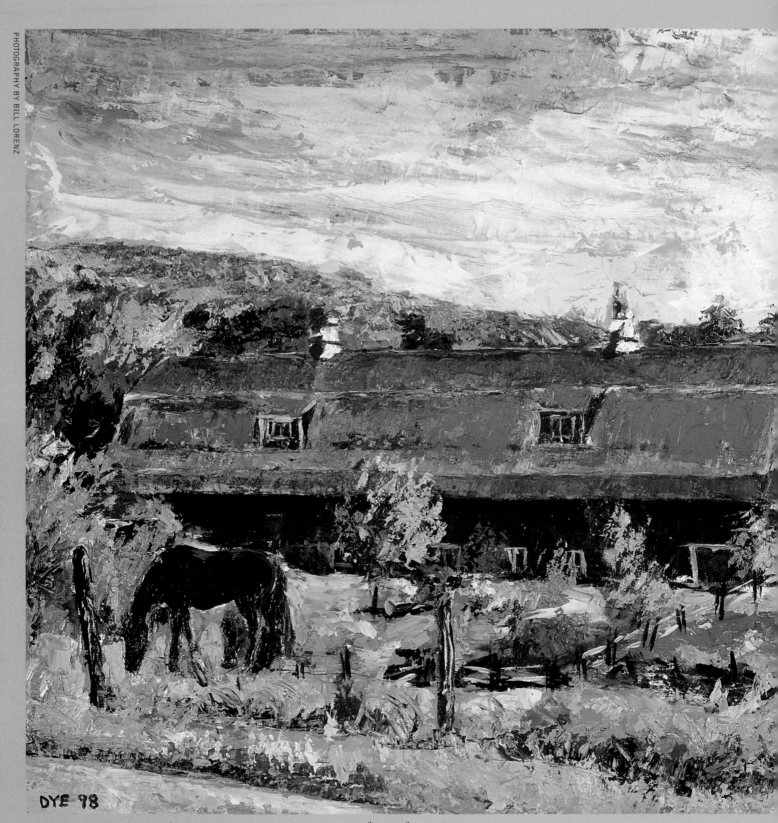

DYE 98

Maple Corner Farm · Sean Dye · Water-soluble oil on panel : 18" X 24" (46cm X 61cm) · Collection of the artist

chapter one

WHAT IS WATER-SOLUBLE OIL COLOR?

That was the question I asked when I heard about this medium. It sounded impossible to me. If it was oil color, how could it possibly be water-soluble? If it was water-soluble, how could it be considered an oil color? I am happy to report that it is possible, and this innovation in fine art materials has stunned artists and art materials dealers alike. This option for artists has revolutionized the way people are thinking about painting. These paints have been a great addition to my studio, and I hope the same will be true for you.

DESCRIPTION OF WATER-SOLUBLE OILS

All oil paints are made by finely grinding pigment into vegetable drying oils. Oil paint has been popular for centuries for a number of reasons:

* Oil in the paint allows the paint to spread easily.
* Oil can dry to a thin durable film for detailed work.
* Oil provides excellent adhesion for the pigment.
* Oil adds transparency to many pigments.
* Oil provides body to retain brush or knife strokes.
* Oil adds depth to the pigment not possible in its dry state.

The new oils are no exception to these benefits. The difference is that the oil vehicle has been modified to make it soluble in water, eliminating the need for harsh or dangerous solvents used to thin the paint and clean brushes and palettes.

There are four major manufacturers currently marketing the new oils in the United States. Each of them has developed their own formulas and methods of making the paint, which is mixable with water. Grumbacher has developed a line called Max Artists' Oil Colors. They are made with alkali-refined linseed oils or, in case of whites to reduce the chance of yellowing, sunflower oils, and factions of other vegetable drying oils.

HK Holbein has produced their Duo Aqua Oil by adding an activator that alters the structure of the linseed oil making it soluble in water. Winsor & Newton have created their Artisan Water Mixable Oil Color paints by using modified linseed and safflower oil. Royal Talens has introduced their version as Van Gogh H₂Oil. It uses a quick-drying, odorless vegetable oil. Both Artisan and Max Oils use all of the traditional pigments in their lines, including cadmiums and cobalts. Van Gogh H₂Oil and Duo Aqua Oil have eliminated heavy metal pigments to reduce toxicity.

You will find that each brand of paint has its own consistency. Holbein's Duo

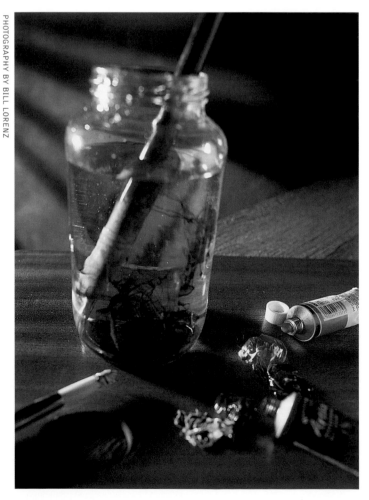

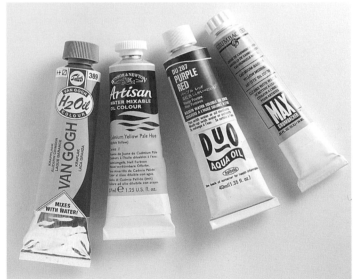

Variety
The four major brands of water-soluble oil paints

Simplicity
Water-soluble oils dissolve easily in water.

Aqua Oil, for instance, has nearly the same rather firm consistency for each of the eighty colors. This makes it ideal for painting with a knife straight from the tube. Winsor & Newton's Artisan and Grumbacher's Max Oils seem to vary slightly depending on which pigment is present. The characteristics of these three brands are consistent with their traditional oil color counterparts. The Van Gogh H$_2$Oils have a soft consistency that is somewhere between that of acrylic paint and honey. This makes them work well for detail without much need for additional mediums. For knife painting, however, they work better with impasto medium added. As you look through this book, you will read the opinions of several different artists. It will be up to you to decide which comments apply to your own working methods. After some experimentation you will be able to decide which brands work best for you. Remember that the mediums offered by one company are completely compatible with paints from another. It is also possible to mix the paint from two different brands to acquire the desired effect. Finally, remember that you can add small amounts of traditional oil color to these paints to affect the color or the consistency.

All traditional oil paint brands have their own distinct odor, which is often pleasant for the painter compared to the smell of solvents. The water-soluble oils also have a different smell for each brand. All of the odors are subtle. Duo Aqua Oils smell the most like traditional oil paint.

The paint tube is labeled with a variety of terms including *water-soluble, water-thinnable, water-mixable* and *water-miscible*. All of these terms mean that the artist can mix the paint successfully with water and clean up with soap and water. I will refer to all of these paints as water-soluble to avoid confusion.

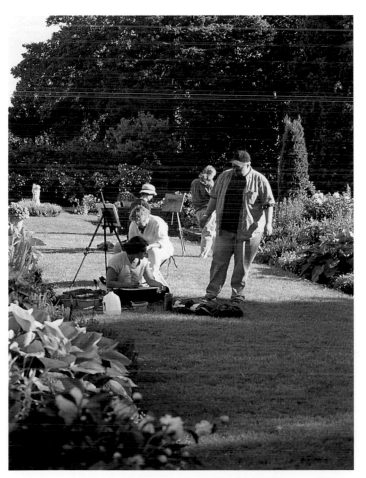

Travel With Ease
Students at the University of Vermont get ready to start their first paintings in a seven-week summer landscape class. For many, it is their first experience with oil paint. Water-soluble oils eliminate the need to bring harsh solvents on location.

COMPARISONS WITH TRADITIONAL OIL COLOR

The idea of making oil paint that can be thinned with water is not an entirely new concept. In fact, water-sensitive oils have been used in commercial applications for nearly thirty years. In fine art applications, it is quite a different story. If an artist tried to mix water with traditional oil color, they would struggle with the antipathy of oil and water (they don't mix). Severe yellowing would likely result because the water would interfere with the drying of the oil. The vegetable oils in oil paint do not dry through evaporation. The solvent evaporates, but the oil is still wet. It must dry through oxidation, absorbing oxygen through the air. Because the vegetable drying oils have been restructured in the new paints, yellowing is eliminated. It is important to remember that all oil paintings that contain linseed oil, including the new water-soluble ones, should not be allowed to dry in the dark or near moisture. This could cause the linseed oil to darken or yellow. Exposure to sunlight can sometimes reverse some of the damage.

Vegetable drying oils are classified as drying, semidrying and nondrying. Nondrying oils are not typically used for painting. Linseed oil, a vegetable drying oil, is made from the ripe seeds of the common flax plant (*Linum usitatissimum*). Safflower oil comes from the safflower plant (*Carthamus tinctorius*), and sunflower oil comes from the sunflower (*Nechanthus annus*). Both are semidrying oils and have less tendency to yellow than linseed oil. Traditionally, modern oils are manufactured by hot-pressing the seeds and sometimes adding steam. Some oils are made by cold-pressing as well. The oils may be processed further to remove impurities through the use of acids or alkali exposure. One of the oldest ways to purify linseed oil is to expose it to light and air for extended periods of time. Another method of purifying linseed oil is to float it on salt water, shaking it occasionally. This will clarify and bleach the oil in a few weeks. Exposing the oil to ozonized air will also purify it.

Oil painting, whether it is traditional or the new water-soluble color, can be used with a tremendously broad range of techniques. The paint can be laid down in many smooth thin layers, called *indirect painting*, or it can be applied in a thick wet single layer called *direct* or *alla prima painting*, and everything in between.

There are several rules for sound oil painting that should be followed for the new oils as well as traditional oils. Typically, thinner, fast drying layers of paint are applied first as a thin wash, as in other mediums, usually called a stain in oil painting. Many experts believe you should be careful how much the oil paint is thinned. If it becomes as thin as a watercolor wash, it may not bind correctly, leading to adhesion problems. One way to avoid this problem is to add 3 to 5 percent damar varnish to the paint (traditional or water-soluble) before thinning. This will increase film strength. The following layers may be thicker or could contain a higher oil content to provide transparency. It is always important to pay attention to the amount of oil in each layer. Oily layers should always be applied over leaner or less oily layers. If the reverse occurs, there is a strong likelihood of cracking, as the drying rates are different. Adding straight oil or mediums that contain oil will fatten the paint by raising the oil content. This will usually make it take longer to dry. Another concern for the oil painter is the fact that the amount of oil in each tube of paint varies with every pigment. Each pigment has a different absorption rate which affects the oil content and drying time (See page 18 for absorption rates).

When painting in either traditional or the new oils, you should wait until the

Mediums are Improved
The linseed oil designed for the new oils has been modified chemically to make it water-soluble.

The Chemistry of Pigment
Pigments come in a dry form. They are ground into a powder and mixed with a binder, vegetable drying oils in the case of oil paint. The oil changes the pigment by adding depth to the color. This richness remains even when the oil paint is completely dry.

early layers are dry before adding new layers. Royal Talens states that early layers of H₂Oil will be ready for overpainting in twenty-four hours. Paints from the other manufacturers will most likely take longer to dry depending on the thickness of application and the pigment.

There are a number of mediums that have been developed specifically for the water-soluble oil colors, including quick-dry mediums, linseed oils, stand oils, painting mediums, alkyd mediums and impasto mediums. The oil paint will remain water-soluble even after these mediums are introduced. Because traditional oil painting is quite old, there are hundreds of mediums and recipes available to artists for a variety of effects. While it is possible to add some of these traditional mediums to the new oils, the water-solubility will diminish very quickly. Solvents may also be used with these new paints, but that eliminates the most important advantage the colors have over standard oil paint. If you cannot find the perfect color in the new paints, small amounts (up to 20 or 30 percent) of traditional oil can be added to the paint and it will remain water-soluble.

Traditional Oil Over Watercolor

This painting was commissioned as a gift from a husband to his wife. The goal was to feature the barn and include the carefully tended gardens. I began the painting with layers of watercolor using primarily warm colors—red, red-orange, yellow and red-violet. Once the watercolor was dry, I blocked in the basic shapes with lean (no added oil) oil color using a large flat brush.

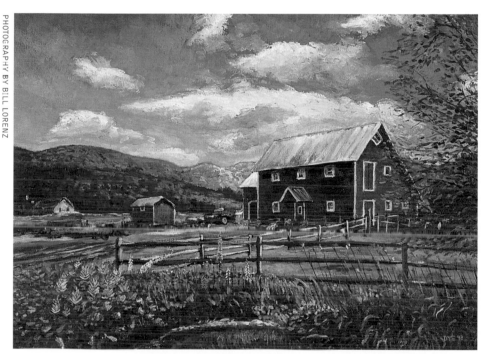

Lilac Mountain Farm · Sean Dye · Water-soluble oil on canvas · 20" X 26" (51cm X 66cm) · Collection of Mr. and Mrs. Steven Yellatt and Julia Blake

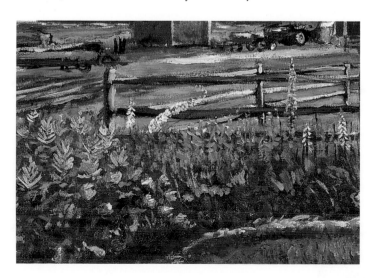

Detail of Lilac Mountain Farm
For the final layers, I added water-soluble linseed oil to make the paint easier to work with for the details such as the flowers.

Although water-soluble oils thin with water like other water mediums, they are truly an oil color. The difference in drying is that after the water has evaporated out of the paint, the oil is still wet and must dry through oxidation. Watercolor, acrylic polymer emulsion colors (acrylic paints) and gouache dry quickly and completely after the water has evaporated. The slower drying time is perhaps water-soluble oil paint's greatest advantage over other water-based mediums. The extended drying time allows the artist time to manipulate the paint before it dries. The plein air painter can keep paint on the palette for long periods of time without the paint drying out.

Perhaps the ancient medium of homemade egg tempera is the closest to the new oils in terms of drying time. Similar to the water-soluble oils, the water in the tempera evaporates, leaving a temporarily fragile surface. The oil from the egg yolk also dries through oxidation, although much faster than oil color. Tempera, however, is very differ-

ent from oil painting in appearance and method of application. Tempera paint, like gouache, dries to a flat, matte finish that may look somewhat lighter than the wet pigment. Tempera is most often applied with a small round brush in a cross-hatching method of many layers. Oil paint, which can be applied with many tools of all sizes, dries to the same value and brilliance as the wet pigment.

Acrylic paint is a little harder to generalize. If used in washes on paper, it will appear very much like watercolor and dry somewhat lighter than the wet color. If the acrylic paint is mixed with a medium such as gloss gel or gloss medium, the dry color will look very much like the wet pigment and remarkably like water-soluble oil paint. Holbein makes a product called Acryla Gouache, an acrylic emulsion paint that has been formulated to dry to a perfectly matte finish like true gouache color. This paint looks nothing like oil paint when dry, but since it dries to a nonglossy and somewhat toothy finish, it is a suitable under-

painting medium for oil paint. Normally acrylic paint is not recommended for this purpose because the oil may have trouble adhering to the nonabsorbent surface. Similarly to acrylic, when dry, oil paint has been altered chemically, so the dry surface is waterproof and can never be brought back to its original state. Watercolor and gouache, in contrast, can be reactivated and reworked with the simple addition of water.

All four manufacturers of the new oils say that it is safe to combine the new oils with traditional oil color. Only two, however, recommend mixing their new oil with other water mediums—HK Holbein and Royal Talens. Holbein suggests adding acrylic paint or mediums to the new oil to speed the drying time. They say that adding small amounts of watercolor will improve the flow of early washes. Royal Talens warns that adding too much of other water mediums will diminish the many desirable and unique qualities of oil color.

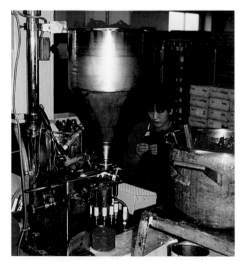

Water-Soluble Oil Paint in the Making
A worker in the Holbein paint factory near Osaka, Japan, fills tubes with oil paint.

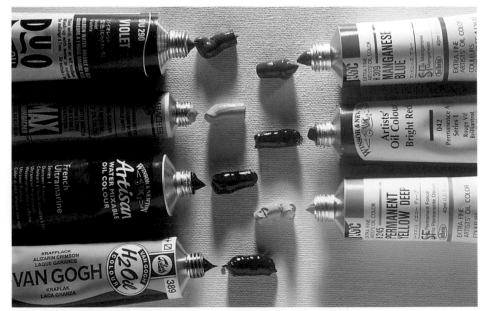

Water-Soluble Oils Look, Feel and Smell Like Traditional Oil Color
Many of the same pigments are used, and there are several painting mediums available to make them behave like their traditional predecessors. The new oils remain workable for extended periods of time but dry slightly faster than the traditional oils.

A BRIEF HISTORY

It is believed that oil painting has been used since the Middle Ages or earlier for crafts, decorative painting and furniture finishes. The first easel paintings were probably various vegetable drying oils and pigment painted over tempera. Jan Van Eyck (before 1395–1441) and his brother Hubert have been credited with mastering oil paints. Modern historians have come to believe, however, that oil painting predates the Van Eycks by at least two or three centuries. The two brothers, along with other Late Gothic Flemish artists, are still credited as being the first to exploit the medium of oil painting to its full potential.

Oil painting first became popular in northern Europe and later spread to Venice, Italy, in the fifteenth century. By the early part of the sixteenth century, oil painting had surpassed tempera as the dominant, acceptable painting medium throughout Europe.

The current view of oil painting's development is that of a gradual evolution of techniques and materials rather than the sudden discovery and overnight employment of the new medium. The advent of water-soluble linseed and other vegetable drying oils can be counted as nothing short of a revolution in the continual development of oil paint. Not since the introduction of acrylic emulsion colors in the 1950s has there been such a significant development in art materials. It is interesting to note that the first acrylic paints, *magna* colors, were not water-soluble and had to be thinned with mineral spirits.

In the late twentieth century, artists—and society in general—became more aware of the dangers inherent in many long-used art materials. The idea of using solvents to paint with has become less popular. By the late 1980s most secondary schools and universities in the United States had banned the use of solvents in art departments and thus eliminated the use of oils in the academic setting. The rationale was that most facilities could not provide ventilation that was adequate, thus exposing students to harmful fumes. Another problem was that paper towels and rags soaked with turpentine or mineral spirits posed a serious fire hazard when not disposed of properly. Many experts feel that the solvents used in oil painting present environmental hazards as well. Improperly discarded solvents can seep into groundwater and lead to health problems in people, plants and animals. If large amounts of solvents are allowed to evaporate, the air quality is seriously compromised. For many artists with small studios or those who have children and animals nearby, using solvents for painting is no longer an option.

For these reasons, among others, the major manufacturers of fine art paints began to develop alternatives to solvent-thinnable oil colors.

Water-Soluble Oil Colors Thin With Water

When the water has evaporated, they are still wet however and must dry slowly through oxidation. Watercolor, gouache and acrylic emulsion colors dry quickly through evaporation. The slower drying water-soluble oils are a good solution for frustrated acrylic painters who struggle to keep their paint wet, especially outdoors. Like acrylic, the new oils are chemically altered when they dry. They cannot be reactivated with water like watercolor and gouache.

PIGMENTS

Oil Absorption

Oil absorption can be described as the smallest amount of vegetable drying oil (linseed, poppy, safflower, sunflower, walnut, etc.) that can be ground into a predetermined amount (100gsm) of a specific pigment. The oil is added slowly until the pigment sticks together and becomes a paste that does not crumble or fall apart. Additional oil, mediums or other additives may be added later to make the pigment workable for the artist. Some manufacturers give a little extra oil for added protection of the pigment. There are many reasons for variations in oil absorbency from pigment to pigment, including a variety of volumes for the same mass, different-shaped particles and varying specific gravities. This information is interesting to know especially if you want to make your own paint; however, it may not be of the greatest concern if you are working with commercially manufactured colors.

The large manufacturers of fine art oil paint formulate the paint to its desired consistency by the addition of oil dryers, extenders and thickeners. This process creates uniformity in most oil paint lines. For this reason, in most cases you don't need to make color choices based upon

oil absorbency. You should use caution, however, in painting fast drying colors of high oil content underneath colors that do not have a relatively high oil content. It should also be noted that the addition of oil or other additives might alter flexibility of the dry paint film.

Drying Time

The approximate drying time of a pigment is important to know when constructing an oil painting. The drying time chart may be used as a rough guide to help you build stable layers of paint. For example, it may be unwise to put pure

Alizarin Crimson (slow drying) under Cobalt Blue (fast drying). The differences in drying rates could cause cracking. To avoid this problem, mix the Alizarin Crimson with a color that has a faster drying time, or add a quick-dry medium. Keep three things in mind: (1) the oil content of the specific oil color, (2) the general drying time of that color, and (3) the amount of oil that you have added by way of mediums or straight painting oil. These guidelines make it relatively simple to follow fat-over-lean rules and thus create a sound oil painting.

HOW MUCH OIL?

The approximate percentage of oil it takes to bind some common pigments into a paste.

High Absorption More than 70 percent	Medium Absorption 55-70 percent	Low Absorption Less than 55 percent
Alizarins	Azos	Cerulean Blue
Burnt Sienna	Cadmiums	Prussian Blue
Burnt Umber	Chromes	Titanium White
Cobalts	Ivory Black (can be high)	Ultramarines
Lamp Black	Oxide of Chromiums	Zinc White
Phthalocyanines	Raw Umber	
Quinacridones	Synthetic Iron Oxides	
Raw Sienna		

DRYING TIME

This chart shows the approximate drying time of some common pigments found in water-soluble oil color. Times will vary with each manufacturer because of different formulations.

Fast Drying	Medium to Fast Drying	Medium Drying	Medium to Slow Drying	Slow Drying	Very Slow Drying
Aureolin	Burnt Sienna	Cadmiums, some	Cerulean Blue	Alizarins	Cadmiums, some
Burnt Umber	Chromium Oxide	Chromes	Dioxazine Purple	Arylide Yellows	Carbon Black
Phthalocyanines	Cobalt Blue	Lamp Black	Ivory Black	Azos	Ivory Black
Prussian Blue	Red Oxides	Titanium White	Yellow Ochre	Quinacridones	Lamp Black
Raw Sienna	Synthetic Iron Oxides	Ultramarines		Zinc White	
Raw Umber	Viridian	Zinc White			

TOXICITY

The greatest pigment hazard for the artist is using the color in its dry form. Once the pigment has been placed into a medium such as oil, acrylic polymer or gum arabic, the hazards are significantly reduced. If caution is used when handling the materials, most experts believe there is very little health risk even when using heavy metal pigments, such as cadmium, cobalt and manganese. There are however some simple common sense rules to abide by:

✳ Do not eat or drink when painting. This could inadvertently put pigment inside your body.

✳ Do not paint with your hands unless you have chemical-proof gloves. These are artists' pigments; if you want to finger-paint, raid a child's art box.

✳ Do not sand or use abrasives on surfaces that have had pigment applied unless you wear an approved respirator and have adequate ventilation.

Disposal is always a problem with oil pigments. It is not a good idea to wash brushes and hands and then let the dirty water go down the drain. This pigmented water will not simply disappear. If the chemicals go to a septic tank, they may end up in groundwater. If you are connected to a municipal sewer, the chemicals could end up in lakes or streams. Many artists now rinse their brushes and dump the rinse water into a plastic bottle or barrel with a tight fitting cap. These containers can then be taken to local hazardous waste drop-offs for a small fee. Some experts believe that letting the water evaporate and disposing of the dried pigment that cakes at the bottom of the rinse bucket is safe for landfills.

TOXICITY OF SOME COMMON PIGMENTS

The relative toxicity of some commonly used artist pigments.

Relatively Harmless— Casual contact represents no significant hazard	Very Low Toxic Hazard— Some precautions necessary when handling	Defined Physiological Hazard— Appropriate precaution necessary
Alizarin Crimson	Aureolin	Barium Chromate
Anthraquinonone Red	Cadmiums	Chrome Yellow
Burnt Sienna	Cobalt Blue	Zinc Yellow
Cerulean Blue	Cobalt Violet	
Dioxazine Violet	Vermilion	
Hansa Yellow		
Naphthol Red		
Oxide of Chromium		
Permanent Red		
Perylene Red		
Phthalocyanines		
Quinacridone Red		
Raw Sienna		
Raw Umber		
Red Oxide		
Rose Madder Genuine		
Terre Verte		
Ultramarine Blue		
Viridian		
Yellow Ochre		

PERMANENCY/LIGHTFASTNESS

Lightfastness of pigments should be of great concern to you. Lightfastness depends on the chemical composition and concentration of the pigment, as well as the medium used. The charts in chapter two give lightfastness ratings for every color in the four brands of water-soluble oil color.

The American Society for Testing and Materials (ASTM) has developed standards for testing lightfastness in a color. If colors are exposed to extreme light for extended periods of time, there could be fading or loss of brightness in a color. Each pigment tested is exposed to sunlight in the southern United States and exposed to indoor light. The pigments are then tested to determine whether or not color loss has occurred and, if so, how much. These tests are voluntary.

Some manufacturers perform their own testing and use their own permanency rating system. A color given the highest rating indicates that there would be no significant color loss for 150 years under normal museum lighting. The second best rating indicates that there would be no significant color loss in 75 years under the same conditions. It is safest to use colors meeting the two highest ratings.

There are several factors that affect the permanency of a color. Application is one. When colors are spread into a very thin film for glazing, there simply is less pigment to hold up over time. Thicker layers of paint are much less prone to fading.

Lighting is another factor. Special glass can be used in homes, galleries and studios to reduce fading of artwork. Low E glass does not allow as much UV (ultraviolet) light into a building, and thus reduces the chance of fading from sunlight. For artwork that is framed under glass, UV protected glazing keeps ultraviolet light away from the pigment. However, most oil paintings are not placed under glass. UV protected varnishes have been developed for paintings in highly lit areas. The painting should dry for six to twelve months before applying any varnish to be sure the oil paint is fully dry. The last consideration is interior lighting. Different lights emit various UV levels. It is best to use a professional lighting consultant for specialized applications.

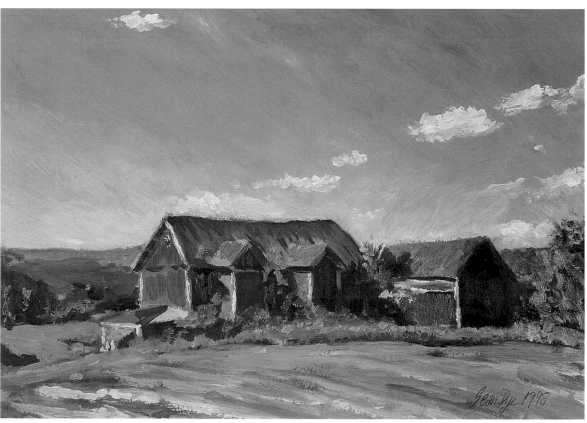

PHOTOGRAPHY BY BILL LORENZ

Be Prepared to Paint at any Time
I saw this barn on a country drive and decided I had to paint it. I had paints with me but no canvas. After searching through the car, I found a light blue tinted watercolor paper that I had prepared for pastel with a clear sanded ground. The surface was wonderful to paint on, and it was interesting to react to the light blue color of the paper rather than a white canvas.

Northeast Kingdom Barn 1 · Sean Dye · Water-soluble oil on Neptune Tinted Watercolor Paper by Strathmore · 9" × 12" (23cm × 30cm) · Collection of the artist

OPACITY AND TRANSPARENCY

The opacity or transparency of an oil color (or any other object) depends on what extent the light rays are bent or refracted as they pass into or through the surface under observation. The charts in chapter two describe the relative transparency for all the colors created by each manufacturer.

All surfaces can be measured and assigned a number that describes what happens to light when it hits that surface. The measurement is known as the refractive index. The higher the assigned refractive index number, the greater the angle of refraction (the bending of light rays) and the more opaque the surface appears to the viewer because more light is reflected. If it is harder for the light to penetrate a color in a straight line, it is also harder to see through that color. If the refractive index value is lower, that means there is less refraction. The color will appear more transparent because light is able to pass through it more easily.

Thin layers of oil paint are technically translucent, or partly transparent. An object that is completely transparent would appear invisible. Things get very complicated when we look at what happens to pigment placed into a medium for painting purposes. Remember first that the greater the difference between refractive indices (when you compare pigment to medium) the more opaque the resulting combination will be. It stands to reason then that the closer the two refractive numbers, the more transparent the paint will be. This is one reason that the same pigment may have different qualities in oil, watercolor, acrylic or tempera paint.

Another factor that may affect transparency is solubility of a pigment in a particular medium. These influences on opacity and transparency may have a significant bearing on how you paint with water-soluble oil color. I was confused at first when I thinned my first set of water-soluble oil colors with water and the paint became less transparent. As soon as the water evaporated, however, the color had the same transparency as it did when oil was the only medium. It is possible that this temporary decrease in transparency is due to increasing the difference in refractive indices. Another possibility is that the emulsion (a suspension of one liquid in another with which it is immiscible) of oil and water is not as transparent as the oil alone.

A very simple way to think of controlling transparency is to regulate the number of pigment particles the viewer looks through in each layer. Suspending pigment in a transparent medium, such as linseed oil or oil painting medium, creates a thin layer of paint called a glaze. The particles are dispersed so that the light rays can penetrate the surface and reveal what lies underneath.

TEXTURE AND APPLICATION

These comparative studies show some common techniques that make up an oil painting. The similarities and differences between traditional oil and water-soluble oil can be seen. Effort was made to match the color and to paint using traditional washes, glazes, knife work and straight paint.

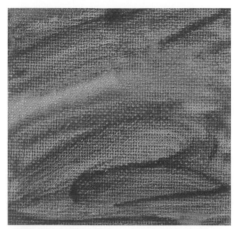

Traditional Oil Color

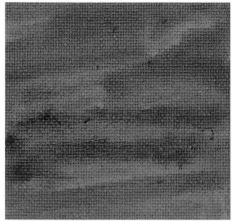

Water-Soluble Oil Color

Traditional Oil Wash vs. Water-Soluble Oil Wash on Gessoed Canvas

The traditional Cobalt Blue oil paint diluted with turpentine, on the left, holds the brushstrokes better than the water-soluble Cobalt Blue oil paint diluted with water, on the right. The water-soluble oil paint appears softer when applied directly to the gessoed canvas. The traditional oil paint dries thicker and more opaquely than the water-soluble oil paint.

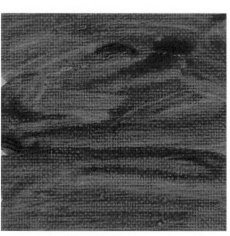

Traditional Oil Color

Water-Soluble Oil Color

Traditional Oil Wash vs. Water-Soluble Oil Wash on Paint

When Cobalt Blue is applied over a base color of Cerulean Blue and Titanium White, the traditional oil paint behaves much the same as it did when applied directly over the gessoed surface. The water-soluble oil paint however, retains brushstrokes better and dries more opaquely than when applied directly to the gessoed canvas.

Traditional Oil Color

Water-Soluble Oil Color

Undiluted Traditional Oil vs. Undiluted Water-Soluble Oil

When coming straight from the tube, there is little difference between traditional oils and water-soluble oils. The undiluted French Ultramarine mixed with Titanium White goes on the canvas opaquely with good brushstrokes for both types of paint.

Traditional Oil With Alkyd Medium vs. Water-Soluble Oil With Winsor & Newton Artisan Fast Drying Medium

Accelerating the drying process slightly affects both types of paint. When Winsor & Newton Liquin, an alkyd medium, is added to Cadmium Yellow Medium paint a smooth semigloss finish is created. When Cadmium Yellow Medium water-soluble paint is combined with the Winsor & Newton Artisan Fast Drying Medium, the paint darkens slightly in color and dries to a glossy finish. Both examples retain their brushstroking and are equal in opacity and were dry in about one hour.

Traditional Oil Color

Water-Soluble Oil Color

Traditional Oil vs. Water-Soluble Oil Impasto Technique

Raw Sienna mixed with Titanium White is painted over tinted gesso using an impasto technique. Water-soluble oil color behaves like the traditional oil when painting with a knife. The strokes of the knife hold with vibrancy, and the glazes are similar. The one exception is that the traditional oil exhibits a more matte finish.

Traditional Oil Color

Water-Soluble Oil Color

Brushstroking Using Traditional Oils vs. Water-Soluble Oils

Water-soluble oil color creates just as detailed brushstrokes as traditional oil color. The Raw Umber over tinted gesso clearly shows the texture and brushstrokes when using either type of paint.

Traditional Oil Color

Water-Soluble Oil Color

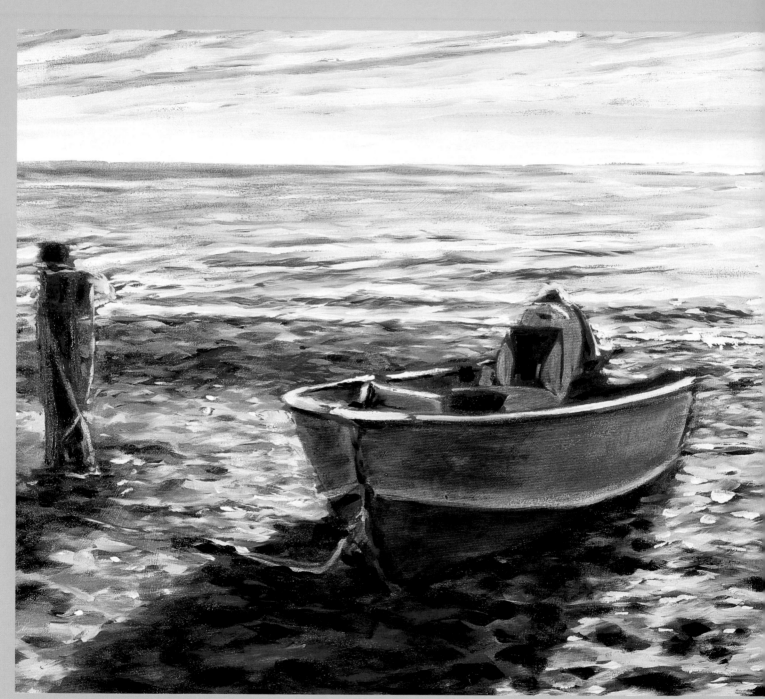

Solitary • Caroline Jasper • Water-soluble oil on canvas • 18"×30" (46cm×76cm)

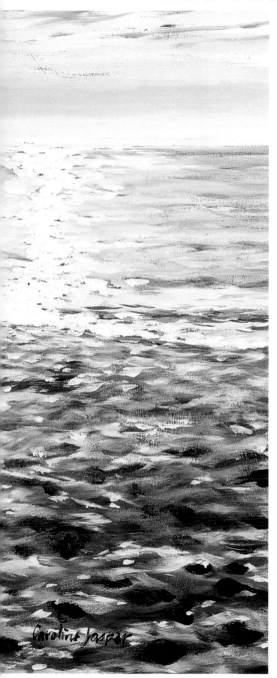

chapter two

WATER-SOLUBLE OIL BRANDS
AND THE TOOLS TO USE

This chapter is designed to give you some of the basics to get you started. Remember, experimentation is the key. Many of the physical qualities of water-soluble oil color are similar to those of traditional oil color.

When talking about oil paint there are five basic qualities that you should consider:

1. Oil absorption

2. Drying time

3. Toxicity

4. Permanency (lightfastness)

5. Opacity and Transparency

The basic physical characteristics of each brand are detailed in this chapter. Each manufacturer tests its paints for opacity and permanency, the results are charted by individual brand. I will also review the tools you need to paint successfully. Everything from your basic brushes to knives and painting supports are discussed here.

The more you paint, the more comfortable you will become with the medium. I find it is best to limit your palette for your first few paintings. After you have painted a few pieces successfully, you will know which colors to add. A good starting palette is: Ultramarine Blue, Cerulean Blue, any warm yellow, Lemon Yellow, Alizarin Crimson, any warm red, Titanium White and Burnt Sienna. Large brushes are best for beginning painters, nos. 8 and larger in flat sizes work the best. Avoid the rounds to begin with. Relax and have fun; that's the point in painting.

MAX GRUMBACHER

After six years of research, Max Grumbacher Oils started to market its Max Artists' Oil Colors. It's a line of sixty colors patented during a complex manufacturing process and is considered the first water-soluble oil line. There is no water in the formula, and the linseed oil binder has been restructured at a molecular level. The result is a product that requires no toxic solvents or chemicals to clean brushes. Water makes it easy to clean up without changing the other characteristics of fine oil pigments.

The Max Artists' Oil Colors are completely nontoxic while still possessing the "beauty, blendability and durability" of oil. They are ideal for painters with allergies to solvents, as well as students and teachers working in buildings without proper ventilation for fumes and solvents. These water-thinnable paints also create fewer health and environmental concerns regarding proper storage, use and disposal of the solvents. They make packing simple for outdoor and traveling painters.

The water-friendly linseed oil medium creates a base that Grumbacher feels is almost perfect compared with ordinary linseed oil, which has a yellowish tinge. Max Oils may actually appear denser and more brilliant than conventional oil colors made with the same pigments because the newly modified oil may be clearer than traditional oil. Max Oils, were subjected to rigorous tests for durability, including the standard ASTM adhesive test performed by an independent lab. The colors were tested under accelerated aging tests and were tested extensively in the field by artists.

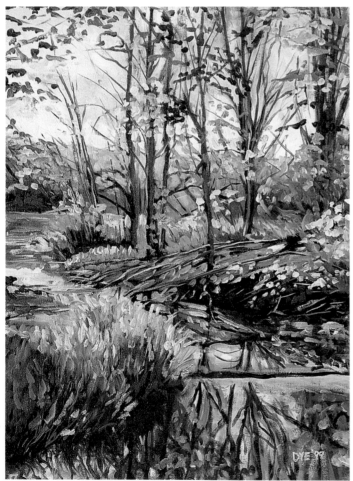

Lake Iroquois Backwater · Sean Dye · Water-soluble oil on sanded gesso on canvas · 24" X 18" (61cm X 46cm) · Collection of the artist

Base Color Adds Warmth

After stretching and priming the canvas with regular acrylic gesso, I decided to create a more textured surface by adding Holbein's LL pumice gesso. I continued by covering the whole canvas with an opaque layer of Yellow Ochre colored gesso. The base color comes through in some areas of the finished painting, adding warmth to a generally cool image. The sky and hill in the background are pale and hazy compared to the brighter and more sharply defined foreground information. This helps to create depth in a composition that is complicated and flattened by the many lines describing trees and branches.

Max Grumbacher Products
The Max Grumbacher line of paints comes in sixty colors.

This chart lists the complete line of Max Grumbacher colors. Pigments are listed if they are not implied by the color name. Transparency and permanence are listed as well.

Pigment	Opacity	Lightfastness
Reds		
Alizarin Crimson	T	III
Cadmium-Barium Red Deep	O	I
Cadmium-Barium Red Light	O	I
Cadmium-Barium Red Medium	O	I
Cadmium-Barium Vermilion	O	I
Grumbacher Red (Naphthol Red)	SO	II
Indian Red (Iron Oxide)	O	I
Perylene Maroon	ST	I
Perylene Red (Anthraquinone Red)	ST	I
Quinacridone Red	ST	I
Thalo Red Rose (Phthalocyanine)	ST	I
Venetian Red (Iron Oxide)	O	I
Oranges		
Cadmium-Barium Orange	O	I
Cadmium-Barium Yellow Orange	O	I
Quinacridone Orange	T	I
Yellows		
Cadmium-Barium Yellow Deep	O	I
Cadmium-Barium Yellow Light	O	I
Cadmium-Barium Yellow Medium	O	I
Cadmium-Barium Yellow Pale	O	I
Diarylide Yellow	T	I
Naples Yellow Hue	O	I
Nickel Titanium Yellow	SO	I
Yellow Ochre	SO	I
Zinc Yellow Hue	SO	II
Greens		
Chromium Oxide Green Opaque	O	I
Green Earth Hue Terre Vert	T	I
Permanent Bright Green	O	II
Permanent Green Light	O	II
Prussian Green	ST	I
Sap Green	T	I
Thalo Green (Blue Shade) (Phthalocyanine)	ST	I
Thalo Green (Yellow Shade) (Phthalocyanine)	ST	I
Thalo Yellow Green (Phthalocyanine)	SO	II
Viridian	T	I

Pigment	Opacity	Lightfastness
Blues		
Cerulean Blue	O	I
Cobalt Blue	ST	I
Cobalt Titanate Blue	O	I
Cobalt Turquoise	O	I
French Ultramarine Blue	T	I
Indanthrone Blue	ST	I
Permanent Blue (Ultramarine Blue)	T	I
Prussian Blue	ST	I
Thalo Blue	ST	I
Ultramarine Blue Deep	T	I
Violets		
Dioxazine Purple	T	I
Thio Violet (Quinacridone Magenta)	T	I
Ultramarine Red	T	I
Browns		
Burnt Sienna	I	I
Burnt Umber	O	I
Flesh Hue	O	I
Golden Ochre Hue Transparent	ST	I
Raw Sienna	ST	I
Raw Umber	O	I
Van Dyck Brown Hue		
Permanent	ST	I
Grays		
Payne's Gray		
Mars Black		
Blacks & Whites		
Ivory Black	ST	I
Lamp Black	SO	I
Titanium White	O	I
Zinc White	SO	I

GRUMBACHER MAX ARTISTS' OIL COLORS

This chart shows some common Max Grumbacher colors in various situations to show variations in transparency, texture and paint handling. Similar variations were used in the other brands for easy comparison.

	Raw Umber	Thalo Green (Blue Shade)	Sap Green	Zinc White	Titanium White	Cadmium Barium Yellow Pale	Cadmium Barium Yellow Medium	Thalo Violet	Ultra-marine Blue	Thio Blue	Alizarin Crimson	Cadmium Barium Red Medium
Straight Color												
Colored Gesso Base												
India Ink Base With Straight Color												
India Ink Base With Linseed Wash												
Acrylic Absorbent Ground Base												
Gouache Base												
Collage Mix With Newspaper and Acrylic Gel Medium												
Tinted With Titanium White												
Tinted With Zinc White												
Holbein LL Gesso (Pumice) Base												
With Winsor & Newton Impasto Medium												

HOLBEIN

In 1989 Holbein scientists began to study the early attempts by other manufacturers at producing water-soluble oil colors. They found other lines to be complicated structurally and not always of high quality. Holbein wanted a genuine oil color consistent with the quality and characteristics of their Holbein Artists' Oil Color.

Holbein's solution to achieving water-soluble oil with the favored attributes of traditional oil was the development of an additive that would act as a *surfactant*, a residue that would lose its effectiveness once the paint dries. A surfactant is a surface-active substance that changes another substance by altering the tension of the surface, much like the surface tension of water changes with the addition of soap, detergents or wetting agents. This manipulation of the surfaces allows a bond to form between oil and water.

Duo Aqua Oil uses a water-soluble linseed oil. Remarkably the oil used is identical to that of traditional oils. There is no special treatment to the oil, no modification or breakdown of the oil and no water added to the product. In fact the only addition to the product is the surfactant, the agent allowing the mixing of oil and water. In addition to being undetectable once dry, it also has no affect on the drying time, as water would in a water-based medium. The surfactant simply covers the pigment and oil making both water-sensitive or soluble, with no other ingredients present.

If an artist chooses not to use water, Duo Aqua Oil may be used as traditional oil color with the same results. It may be blended with traditional oil color or medium and will remain water-soluble as long as the amount of traditional oil does not exceed 30 percent. For mixtures over 30 percent, the artist will be making a conventional oil painting.

The Holbein chemists believe that Duo Aqua Oil can be mixed safely with gouache, watercolor and acrylic paints, although small amounts of water should be added to the acrylic paints and acrylic gouaches when mixed with the Duo Aqua Oils.

Like other water-soluble colors, Duo Aqua Oil starts to dry slowly after the water evaporates out of the oil. The oil that remains continues to dry by oxidation in the same manner as traditional oil color and with the same appearance and structure. It is an organic paint surface that expands and contracts with changes in temperature and humidity.

Holbein 220 Hard Resable Brushes

Holbein has developed the Resable line of oil brushes to use with the Duo Aqua Oil paint. While many artists like to work with hog bristle brushes for oil painting, problems occur when the brushes are soaked in water. The brushes may become waterlogged, making them floppy and unresponsive. Acrylic brushes are designed with the soft consistency of acrylic paint in mind. The Resable is hardened nylon that is not harmed by soaking in water and is firm enough to work the water-soluble oil.

Holbein Duo Aqua Products

The Duo Aqua Oil line consists of 80 colors, which is smaller than their popular Artists' Oil Colors, which has 170 colors. The heavy metal pigments were removed to insure a nontoxic result. All other pigments remain the same as the traditional oil line (although some names have changed), which allows artists to use the same painting techniques. The paints have a similar drying time, and artists can expect the same permanency characteristics.

This chart lists the complete line of Holbein Duo Aqua Oil. Pigments are listed if they are not implied by color name. Transparency and permanence are listed as well.

Pigment	Opacity	Lightfastness
Reds		
Alizarin Crimson	T	**
Madder (PR221)	T	***
Rose (PR144)	T	***
Scarlet (Naphthol Red, PO69)	ST	**
Red (Naphthol Red)	O	**
Deep Red (Naphthol Red, PO188)	O	**
Purple Red (PR185)	SO	**
Vermilion (Azo pigment PR188, PO69)	O	**
Oranges		
Coral (Naphthol, Titanium Dioxide)	O	**
Pink (Naphthol, Titanium Dioxide)	O	*
Orange (PR185, Arylide yellow [Hansa])	O	***
Yellows		
Jaune Brilliant (Naphthol Red, Arylide Yellow, [Hansa], Titanium Dioxide)	O	**
Cream (PY14, Yellow Oxide, Titanium)	O	***
Lemon (Arylide Yellow [Hansa], Titanium)	ST	**
Yellow Ochre (Yellow Oxide)	O	****
Aureolin (Arylide Yellow [Hansa], Isoindolinone)	T	***
Light Yellow (Arylide Yellow [Hansa], PY152, Titanium)	O	***
Yellow (Arylide Yellow [Hansa], PY152, Titanium)	O	***
Deep Yellow (PY152, Titanium)	O	***
Marigold (Isoindolinone Yellow, PY128)	T	***
Greenish Yellow (PY117)	ST	***
Greens		
Viridian (Phthalocyanine Green [Phthalo Green])	T	***
Emerald Green (Phthalocyanine Green [Phthalo Green], Titanium)	O	**
Cobalt Green (Phthalocyanine Green [Phthalo Green], Phthalo Blue, Titanium)	ST	***
Terre Verte (Native Earth) (Yellow Ochre, Hooker's Green)	ST	***
Sap Green (PY128, Phthalocyanine Green [Phthalo Green])	T	***
Light Green (PY14, Phthalocyanine Green [Phthalo Green])	O	***
Green (PY14, Nickel Titanium Yellow, Phthalocyanine Blue [Phthalo Blue])	O	***
Deep Green (PY14, Phthalocyanine Blue [Phthalo Blue], Titanium)	O	**
Yellow Green (Arylide Yellow, Nickel Titanium Yellow, Phthalocyanine Green [Phthalo Green])	O	***
Prussian Green (PY14, Nickel Titanium Yellow, Phthalocyanine Green [Phthalo Green])	O	***
Leaf Green (Yellow Ochre, Nickel Titanium Yellow, PY128)	O	***
Olive Green (Anthraquinoid Red, PY128, Phthalocyanine Green [Phthalo Green])	ST	***
Mint Green (Phthalocyanine Green [Phthalo Green] Titanium)	O	**
Ice Green (Phthalocyanine Green [Phthalo Green], Titanium)	O	***
Blues		
Cobalt Blue (Ultramarine, Phthalocyanine Blue [Phthalo Blue], Titanium)	SO	***
Cerulean Blue (Phthalocyanine Blue [Phthalo Blue], Ultramarine, Titanium)	SO	**

Pigment	Opacity	Lightfastness
Ultramarine Blue (Ultramarine)	T	***
Prussian Blue (Prussian Blue)	O	**
Indigo (Prussian Blue, Ultramarine)	O	***
Blue (Phthalocyanine Blue [Phthalo Blue], Ultramarine, Titanium)	SO	***
Turquoise Blue (Phthalocyanine Blue [Phthalo Blue], Titanium)	SO	***
Navy Blue (Phthalocyanine Green [Phthalo Green], Ultramarine)	T	***
Marine Blue (Phthalocyanine Blue)	T	**
Green Blue (Metal-free Phthalocaynine, Blue)	ST	***
Horizon Blue (Phthalocyanine Blue [Phthalo Blue], Titanium)	O	**
Sky Blue (Ultramarine, Titanium)	O	**
Violets		
Violet (Quinacridone Magenta, Ultramarine)	SO	*
Mauve (Ultramarine, PV5)	O	**
Blue Violet (PV37)	ST	****
Rose Violet (Quinacridone Magenta)	T	***
Light Magenta (Quinacridone Violet, Titanium)	O	***
Lilac (PV37, Titanium)	O	**
Lavender (Ultramarine, Titanium)	O	***
Browns		
Brown (Indian Red)	O	****
Raw Umber (Natural Brown Iron Oxide)	ST	****
Raw Sienna (Yellow Ochre)	ST	****
Burnt Umber (Natural Brown Iron Oxide)	ST	****
Burnt Sienna (Natural Brown Iron Oxide)	ST	****
Sepia (NBr8 Ivory Black)	SO	****
Caramel (Anthraquinoid Red, Isoindolinone Yellow)	T	***
Grays		
Rose Grey (Indian Red, Titanium)	O	****
Yellow Grey (Indian Red, Mars Yellow, Titanium)	O	***
Orange Grey (PBr11, Titanium)	O	***
Green Grey (Chromium Oxide Green, Titanium)	O	***
Blue Grey (Ultramarine, Titanium)	O	***
Violet Grey (Indian Red, Ultramarine, Titanium)	O	***
Payne's Grey (Ultramarine, Titanium)	O	***
Monochrome 1 (V-8) (Mars Yellow, Natural Brown Iron Oxide, Titanium)	O	***
Monochrome 2 (V-6) (Mars Yellow, Natural Brown Iron Oxide, Titanium)	O	***
Monochrome 3 (V-4) (Mars Yellow, Natural Brown Iron Oxide, Titanium)	O	***
Blacks & Whites		
Ivory Black (Carbon, Ivory)	O	****
Mars Black (Mars)	O	****
Permanent White (Titanium)	O	****
Titanium White (Titanium)	O	****
Luminous		
Luminous Opera		
Luminous Red		
Luminous Orange		
Luminous Lemon		
Luminous Green		

These colors are not listed for permanency or lightfastness.

HOLBEIN DUO AQUA OIL COLORS

This chart shows some common Holbein colors in various situations to show variations in transparency, texture and paint handling.
Similar variations were used in the other brands for easy comparison.

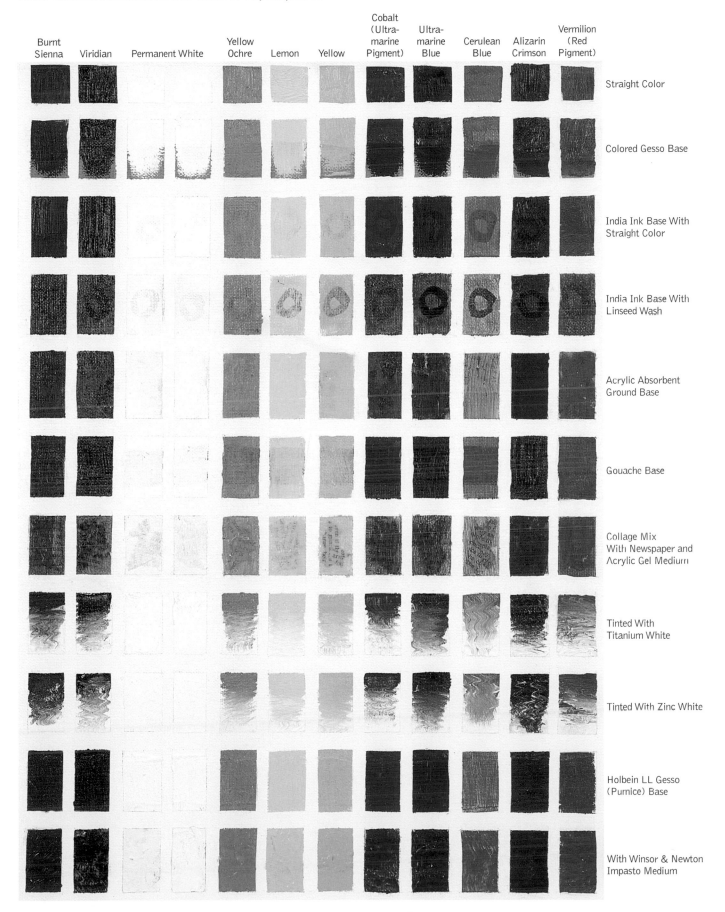

VAN GOGH

Van Gogh H₂Oil, made by Royal Talens, is a completely water-soluble oil line. Water is the key for thinning and mixing these paints, yet no water is added to the product. Unlike acrylic, H₂Oil color holds a brushstroke completely, just as one would expect with oils, so a stroke won't fall to gravity. The H₂Oil is also the softest of the four brands when it comes out of the tube. I found the texture to be the closest to acrylic paint of the four brands. The soft consistency makes it easy to blend, making it very suitable for detailed work. The paint can easily be made stiffer by adding small amounts of Winsor & Newton Impasto Medium. In this way the H₂Oil can hold high knifestrokes and brushstrokes.

Due to the vegetable drying oils used, the colors dry up to four times faster than conventional oils. Thin coats may be painted over in twenty-four hours. H₂Oil seems to be the fastest drying paint of the four brands available.

To paint successfully with H₂Oils, you must adhere closely to traditional oil painting techniques. As with the oils, in water-soluble color you must paint thick over thin, perhaps by beginning with a base coat of Van Gogh H₂Oil thinned liberally with water. Then proceeding layers are painted with a decreasing amount of water, until straight H₂Oil is used. Since the Van Gogh H₂Oil line does not have mediums of its own, I recommend using the mediums found in the other lines which are fully compatible. The H₂Oils can be manipulated in a variety of ways, making the experience closer to the traditional oil experience.

Van Gogh H₂Oil may be mixed with conventional oil color but water solubility will be compromised. It may also be mixed with acrylic paints or mediums, but that will decrease the oil-like qualities of brushstrokes. If a solvent is used instead of water, drying time will remain the same, and if a medium is used, the drying time will increase.

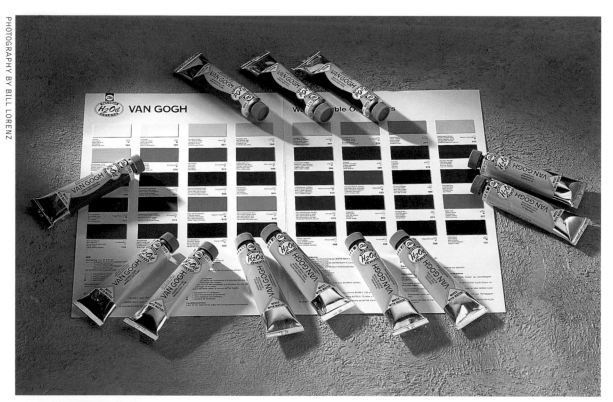

Van Gogh H₂Oil Products
H₂Oil color holds a brushstroke completely, just as traditional oils would, but can be thinned with water.

This chart lists the complete line of Van Gogh H₂Oil colors. Pigments are listed if they are not implied by color name. Transparency and permanence are listed as well.

Pigment	Opacity	Lightfastness
Reds		
Vermilion (Benzimidazolone)	SO	++
Naphthol Red Light (Naphthol Diarylide)	SO	++
Naphthol Red Medium	SO	++
Alizarin Crimson (Quinacridone Naphthol)	ST	++
Light Oxide Red (Synthetic Iron Oxide)	O	+++
Carmine (Anthraquinone)	ST	+++
Carmine Deep	ST	++
Madder Lake (Naphthol)		
Quinacridone Rose	T	+++
Oranges		
Naples Yellow Red (Zinc Oxide, Benzimidazolone, Antimony/chromium/titanium Oxide)	O	+++
Azo Orange (Benzimidazolone, Diarylide)	SO	++
Yellows		
Azo Yellow Lemon (Zinc Oxide, Arylide)	SO	++
Azo Yellow Light (Benzimidazolone)	SO	+++
Azo Yellow Medium (Benzimidazolone)	SO	+++
Azo Yellow Deep (Benzimidazolone, Diketopyrrolo-pyrrole)	SO	+++
Indian Yellow (Isoindolinone)	T	+++
Yellow Ochre (Synthetic Iron Oxide)	O	+++
Naples Yellow Deep (Zinc Oxide, Diketopyrrolo-pyrrole, Antimony/chromium/titanium Oxide)	O	+++
Greens		
Permanent Green Medium (Benzimidazolone, Chlorinated Copper Phthalocyanine)	SO	+++
Emerald Green (Titanium Dioxide, Benzimidazolone, Chlorinated Copper Phthalocyanine)	P	+++
Permanent Green Light (Benzimidazolone, Chlorinated Copper Phthalocyanine)	SO	+++
Permanent Green Deep (Benzimidazolone, Chlorinated Copper Phthalocyanine)	SO	+++
Sap Green (Chlorinated Copper Phthalocyanine, Isoindolinone)	T	+++
Phthalo Green (Chlorinated Copper Phthalocyanine)	T	+++

Pigment	Opacity	Lightfastness
Blues		
Ultramarine Blue (Copper Phthalocyanine Dioxazine)	T	+++
Cobalt Blue (phthalo) (Copper Phthalocyanine Dioxazine, Titanium Dioxide)	SO	+++
Cerulean Blue (Zinc Oxide, Copper Phthalocyanine)	O	+++
Prussian Blue (Ferric-ferrocyanine)	T	+++
Phthalo Blue (Copper Phthalocyanine)	O	+++
Turquoise Blue (Titanium dioxide, Copper Phthalocyanine, Chlorinated Copper Phthalocyanine)	O	+++
Violets		
Permanent Red Violet (Dioxazine Quinacridone)	ST	+
Permanent Blue Violet (Dioxazine Quinacridone)	ST	+++
Browns		
Van Dyke Brown (Synthetic Iron Oxide)	SO	+++
Burnt Sienna (Synthetic Iron Oxide)	ST	+++
Burnt Umber (Synthetic Iron Oxide)	ST	+++
Raw Umber (Synthetic Iron Oxide)	ST	+++
Grays		
Payne's Grey (Bone Black, Copper Phthalocyanine, Quinacridone)	SO	+++
Blacks & Whites		
Ivory Black (Bone Black)	O	+++
Zinc White (Zinc Oxide)	SO	+++
Titanium White (Titanium Dioxide)	O	+++

VAN GOGH H₂O OIL COLORS

This chart shows some common Van Gogh H₂Oil colors in various situations to show variations in transparency, texture and paint handling. Similar variations were used in the other brands for easy comparison.

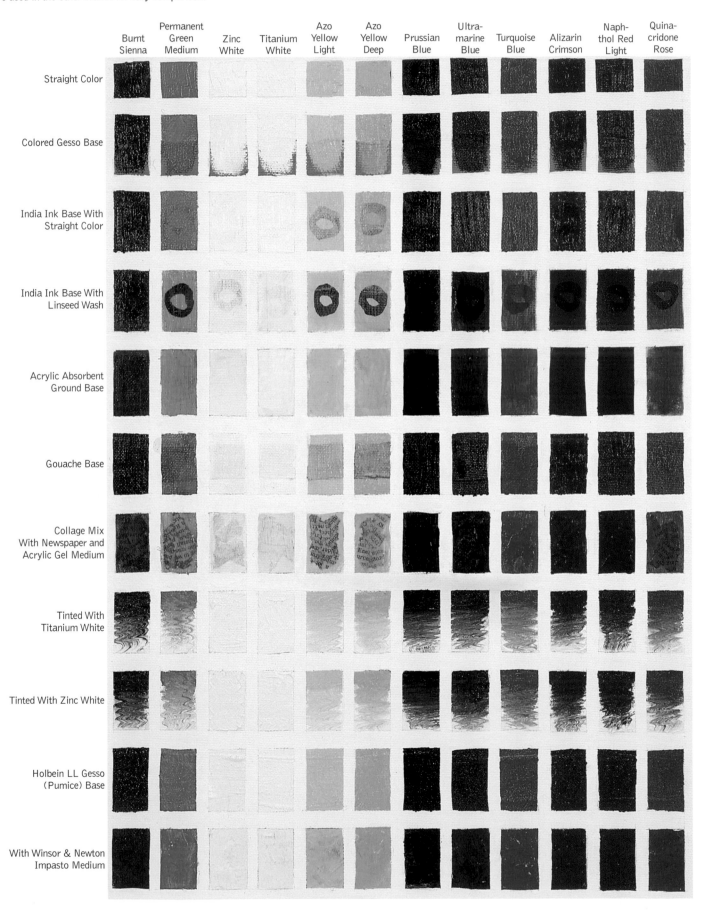

WINSOR & NEWTON

Renowned throughout the art world, Winsor & Newton has manufactured fine art materials for over 166 years. Continuous research and development provide Winsor & Newton with the knowledge needed to improve their merchandise and ensure the quality of a modern product while still retaining the feeling of traditional fine art materials. This dedication to scientific innovations in their products has always been vital.

Winsor & Newton's reputation for manufacturing oil paints has earned the respect of many artists and made their Artists' Oil Colors a highly popular line. The company also manufactures acrylic and watercolor lines, natural and synthetic brushes and many other products.

In 1997 the Artisan Water Mixable Oil Colors and Artisan Mediums line was added to the palette of Winsor & Newton products. This line consists of forty colors and five nonhazardous water-mixable mediums: oil painting medium, linseed oil, stand oil, fast drying medium and impasto medium.

The line offers variable opacities and genuine oil color with traditional oil pigments. For the health and environmental conscious, the water-soluble trait adds the advantage of a safe cleanup with water, eliminating the use of hazardous solvents, thus requiring no health labeling. The tubes are also safe for air travel. A viscous, buttery consistency replicates the effects of traditional oils. In addition to achieving a wide range of color using strong single pigments, these colors exhibit the conventional two to twelve-day drying time.

The five mediums handle similarly to conventional oil mediums, allowing you to change the consistency of the paints. The addition of mediums makes it easier to build multiple layers and to control drying times.

Winsor & Newton has developed Artisan Brushes to be compatible with the water-soluble oils. These synthetic brushes, with superior spring and straightness, perform like hog bristle brushes but maintain shape and stiffness even during prolonged soaking in water. Hog bristles expand when soaked in water providing the potential to lose their shape and flexibility. The Artisan Brushes offer excellent spring, strength and durability in a range of different head shapes and sizes. Other types of synthetic brushes are not ideally suited for oil painting because they have been designed with softer bristles for watercolor or acrylic paint.

The water-miscible colors were created to satisfy the relevant health concerns and to maintain artistic qualities of the oil color. Prior to the launch of Winsor & Newton's Artisan line, other manufacturers introduced their lines but without compatible mediums. Winsor & Newton set out to make a line with mediums, thus preserving the innate characteristics of oil painting.

Winsor & Newton Silver Brushes

Winsor & Newton has developed a line of brushes to be used with their water-soluble oil color. The nylon bristles are firmer than normal acrylic brush bristles so that the stiffer oil paint can be moved more easily.

PHOTOGRAPHY BY BILL LORENZ

PHOTOGRAPH COURTESY OF WINSOR & NEWTON

Full Line of Winsor & Newton Artisan Water Mixable Oil Color

This chart list the complete line of Winsor & Newton Artisan Water Mixable Oil Colors. Pigments are listed if they are not implied by color name. Transparency and permanence are listed as well.

Pigment	Opacity	Lightfastness
Reds		
Cadmium Red Light (Cadmium Sulphoselenide)	O	A
Cadmium Red Medium (Cadmium Sulphoselenide)	O	A
Cadmium Red Hue (Naphthol AS Red, Naphthol Carbamide)	T	A
Cadmium Red Dark (Cadmium Sulphoselenide)	O	A
Cadmium Red Deep Hue (Naphthol Carbamide, Bezimidazolone)	T	A
Permanent Rose (Quinacridone Red)	T	A
Permanent Alizarin Crimson (Quinacridone Pyrrolidone)	T	A
Oranges		
Cadmium Orange Hue (Perinone Orange)	T	A
Yellows		
Cadmium Yellow Light (Cadmium Zinc Sulphide)	O	A
Lemon Yellow (Arylide Yellow)	T	A
Cadmium Yellow Pale Hue (Arylide Yellows)	T	A
Cadmium Yellow Medium (Cadmium Zinc Sulphoselenide, Cadmium Sulphoselenide)	O	A
Cadmium Yellow Hue (Arylide Yellow)	T	A
Cadmium Yellow Deep Hue (Arylide Yellow, Perinone Orange)	T	A
Naples Yellow Hue (Synthetic Iron Oxides, Titanium Dioxide)	O	A
Yellow Ochre (Synthetic Iron Oxides)	O	AA
Greens		
Viridian (Hydrated Chromium Oxide)	T	AA
Phthalo Green (Blue Shade) (Chlorinated Copper, Phthalocyanine)	T	A
Phthalo Green (Yellow Shade) (Chlorinated and Brominated Phthalocyanine)	T	A
Permanent Sap Green (Quinacridone, Brominated Copper, Phthalocyanine)	T	A
Olive Green (Quinacridone, Carbon Black)	T	A

Pigment	Opacity	Lightfastness
Blues		
Cobalt Blue Hue (Indanthrome, Complex Silicate of Sodium and Aluminum with Sulphur)	O	A
Cobalt Blue (Oxides of Cobalt and Aluminum)	T	AA
Cerulean Blue Hue (Oxides of Cobalt and Chromium, Zinc Oxide)	O	AA
Cerulean Blue (Oxides of Cobalt and Tin)	O	AA
French Ultramarine (Complex Silicate of Sodium and Aluminum with Sulphur)	T	A(iii)
Prussian Blue (Alkali Ferriferrocyanide)	T	A
Phthalo Blue (Red Shade) (Copper Phthalocyanine)	T	A
Violets		
Dioxazine Purple (Carbazole Dioxazine)	T	A
Magenta (Quinacridone)	T	A
Browns		
Raw Umber (Natural Iron Oxide containing Manganese)	T	AA
Raw Sienna (Yellow Ochre)	T	AA
Burnt Umber (Calcined Natural Iron Oxide)	T	AA
Burnt Sienna (Calcined Natural and Synthetic Iron Oxide)	T	AA
Indian Red (Synthetic Iron Oxide)	O	AA
Grays		
Payne's Gray (Complex Silicate of Sodium and Aluminum with Sulphur, Amorphous Carbon)	O	A
Blacks & Whites		
Ivory Black (Amorphous Carbon produced by charring animal bones)	O	AA
Lamp Black (Amorphous Carbon)	O	AA
Zinc White (Zinc Oxide, Titanium Dioxide)	O	AA
Titanium White (Titanium Dioxide, Zinc Oxide)	O	AA

WINSOR & NEWTON ARTISAN WATER MIXABLE OIL COLORS

This chart shows some common Winsor & Newton Water Mixable Artisan Oil Colors in various situations to show variations in transparency, texture and paint handling. Similar variations were used in the other brands for easy comparison.

Columns (left to right): Burnt Sienna, Phthalo Green (Blue Shade), Zinc White, Titanium White, Yellow Ochre, Lemon Yellow, Cadmium Yellow Medium, Cobalt Blue, French Ultramarine, Cerulean Blue, Permanent Alizarin Crimson, Cadmium Red Medium

Rows (top to bottom): Straight Color; Colored Gesso Base; India Ink Base With Straight Color; India Ink Base With Linseed Wash; Acrylic Absorbent Ground Base; Gouache Base; Collage Mix With Newspaper and Acrylic Gel Medium; Tinted With Titanium White; Tinted With Zinc White; Holbein LL Gesso (Pumice) Base; With Winsor & Newton Impasto Medium

BRUSHES

It is a good idea to equip yourself with a few good brushes. Your local retailer will be able to help you find a brush that fits your needs. As a general rule, oil and acrylic brushes have long handles; watercolor brushes have short handles. If you are just starting out, avoid small brushes. I allow my students only two brushes for their first semester of painting: nos. 8 and 12 flat, bright or filbert.

After the first semester, they can introduce rounds, fans and slightly smaller brushes to their toolbox. You might find it very educational to start out with a limited number of brushes. With fewer options you can focus on painting and not become caught up in the materials.

Natural vs. Synthetic?
I have used natural hog bristle brushes for years. They have a firm flexible tip as long as they don't soak in water for an extended period of time. Lately, however, I have experimented with various brands of nylon brushes. Harder bristles have been developed for use with the water-soluble oils, and softer bristle brushes work well for acrylics or glazing with oils.

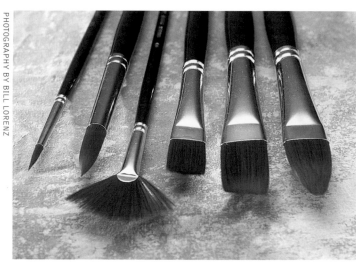

Brushes
The brushes pictured here, from left to right, are no. 4 round, no. 10 round, no. 6 fan, no. 10 bright, no. 12 flat and no. 12 filbert. All of the brushes are Resable hardened nylon by Holbein.

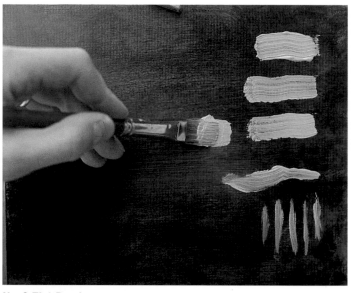

No. 8 Flat Brush
Notice the long bristles characteristic of the flat brush.

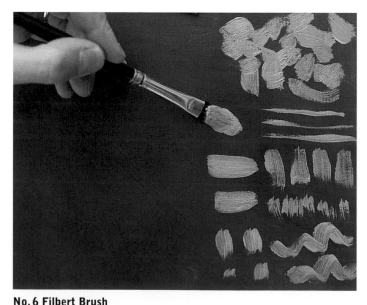

No. 6 Filbert Brush
Notice the tapered end of the filbert brush.

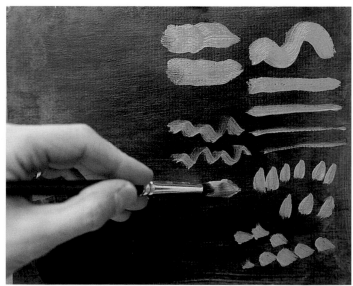

No. 8 Round Brush
Round brushes are used for painting details.

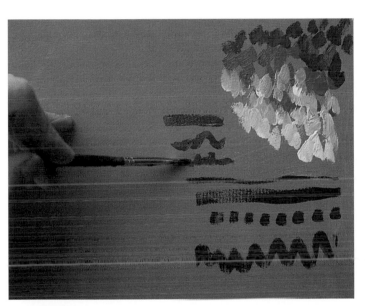

No. 4 Flat Brush
Flat brushes can be used to create a variety of strokes.

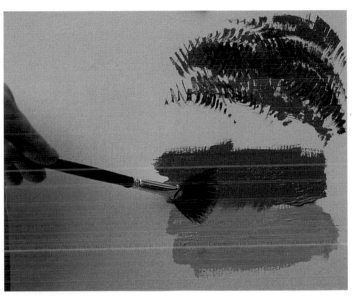

No. 4 Fan Brush
Blend with a no. 4 fan brush.

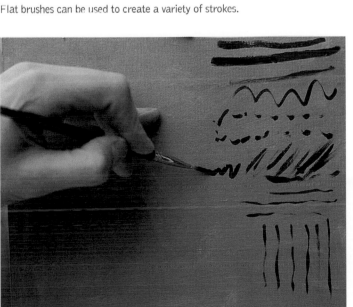

No. 4 "Maxon" Rigger Brush by Holbein
Notice the long slender point.

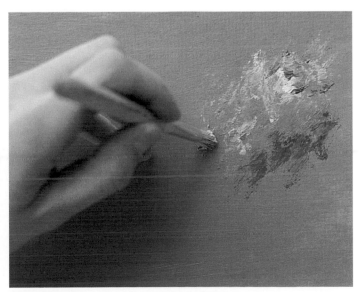

Stencil Brush
You can use a stencil brush for a dabbing effect.

KNIVES

Like most other art materials, you get what you pay for when it comes to painting knives. A cheap knife will work like a cheap knife. You must be sure your knife is made of stainless steel since water may come into contact with the blade when using water-soluble oils. The size, shape and flexibility of the blade you choose will depend on several factors including the size of the painting, the style of presentation, the level of detail desired and the texture or viscosity of the paint to be used. I would recommend buying one good quality knife to begin with. I do about 80 percent of my knife painting with a no. 10 series SX by Holbein. It has a fairly stiff 2½-inch (60mm) tapered blade that ends in a rounded point. This is a good all-purpose size and shape.

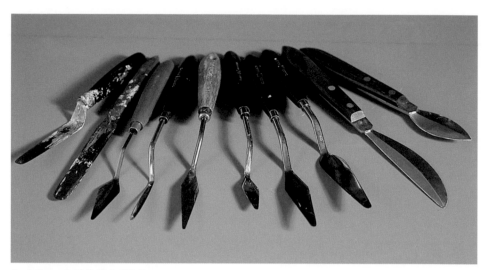

Assortment of Artists' Knives
The two knives on the left are palette or mixing knives. The six knives in the middle are painting knives. The two on the right side are canvas scrapers.

Small Color-Shaper
Place the paint where you want it with a small color shaper.

Rubber-Tipped Color-Shaper
Use a rubber tipped color shaper to push paint around.

No. 1 Painting Knife
This small painting knife can create fine details.

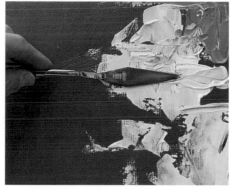

No. 4 Painting Knife
You can cover large amounts of your painting surface to produce interesting textures and layers.

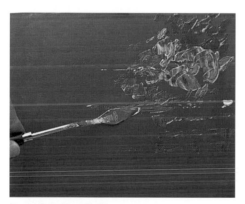

No. 7 Painting Knife
Painting knives create a variety of textures.

Palette Knife
Paint with the flat edge of your palette knife.

Create Your Own Tools
A scrap of painted linen prints texture on the board.

Painting Card
Use a small "painting card" made from a scrap of mat board to apply texture. Old library cards, ATM cards and credit cards work well too.

SUPPORTS, GROUNDS AND MEDIUMS

Your painting support and ground greatly affect your painting experience. The most common surface for oil painting is a cotton canvas stretched over a wooden frame called a stretcher. To increase longevity and variety of texture, linen may be substituted for cotton canvas, but it is more expensive.

Commercially prepared hardboard and plywood panels are good to work on if you desire a more rigid support. You can prepare your own painting panels if you are willing to do some sanding and apply your own grounds.

Paper is another support that will work well for oils if properly cared for. I recommend using only 100 percent cotton paper, which will last longer than ordinary wood fiber paper. Paper should always be primed before painting with oil color. I use a thin coat of gesso (one part gesso to one part water) or two coats of acrylic gesso. It is helpful to tape or staple your paper down before adding the gesso. Use a large house painting brush to apply the gesso/water mixture.

I use acrylic gesso as a starting ground for all of the paintings that I do. Sometimes I will add a foundation oil color on top of the gesso to build up the surface before I begin painting. The foundation oil color can be thinned with mineral spirits or used straight. Allow it to dry at least two weeks before beginning your painting.

Many purist oil painters prefer to use a traditional dry gesso mixture that usually contains rabbit skin glue, precipitated chalk and white pigment. This type of gesso works best on panels and is not ideally suited for flexible canvas supports because it may become brittle with age. There are several paint additives or mediums on the market today which can meet your needs.

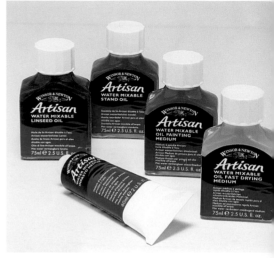

Mediums
Winsor & Newton makes an extensive line of painting mediums for their Artisan Water Mixable Oil Colors.

Mastering the Medium
George Teichmann is a master of traditional oil painting technique. He is able to do anything with water-soluble oils that he can do with traditional oils.

Shameful Retreat · George Teichmann · Water-soluble oil on canvas · 25" X 48" (64cm X 122cm)

BASIC SETUP

Water

After you buy your paint, brushes, knives, canvas or panels, and palette, you need to think about setting up for the process of painting. You will need access to water or a way to store some conveniently. Until recently I did not have running water in my studio. Every couple of days I would bring empty plastic milk jugs to the house and full ones back to the studio. I keep a few right next to my easel even now that I have running water.

Light

Good light is important for painting. If you do not have the luxury of natural light then take a look at what you can do for good artificial lighting. If you have fluorescent fixtures, invest in a few full-spectrum lightbulbs. This will make any dark work space feel like it is getting natural daylight. For more direct lighting, swing-arm lamps and clip-on utility lights work well if you use full-spectrum incandescent lightbulbs.

Palette

In the photograph below, you can see my beautiful wooden palette that came with my portable French easel. Notice how clean it is? I can't bring myself to put paint on it. I prefer polystyrene meat trays, disposable palette pads and glass palettes. You can buy glass palettes with the traditional thumbhole. If the hole is not important to you, go to a hardware store and buy a 9" × 12" (23cm x 30cm) piece of glass. Tape a piece of white mat board on the back and voila—instant palette. To remove dried paint from a glass palette, use a single-edged razor.

Towels

I keep paper towels, toilet tissue and old rags near my easel. When I am knife painting, I clean off the knife with toilet tissue after each time my knife hits the canvas. This keeps my colors clean and bright. I use a fair amount of toilet tissue, so I always use recycled brands.

When I am painting with a brush, I use paper towels to remove excess paint from the brush. After each use, I rinse the brush in water. Then I squeeze the brush with a paper towel to remove excess water and avoid unexpected drips. I keep rags nearby to remove unwanted paint from the canvas or panel that I am working on.

Brush Cleaners

With water-soluble oil color there is no need for solvents to clean up. Soap is very helpful however. Holbein makes a liquid brush cleaner for its Duo Aqua Oil line. Another popular cleaner is The Masters by General Pencil.

After rinsing your brush in water, swish it in a small container of liquid brush soap or massage the solid variety into the bristles. Your brush is clean when you no longer see color in the rinse water.

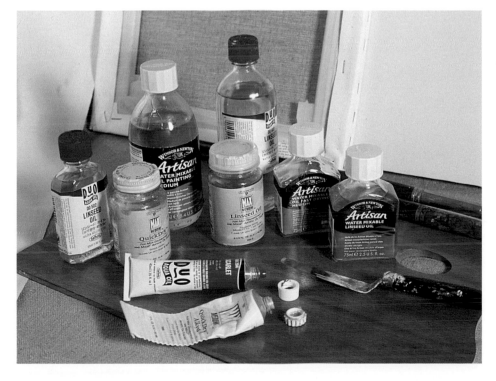

Mediums and Palette
This photograph shows the various mediums, supports and tools to choose from for your painting.

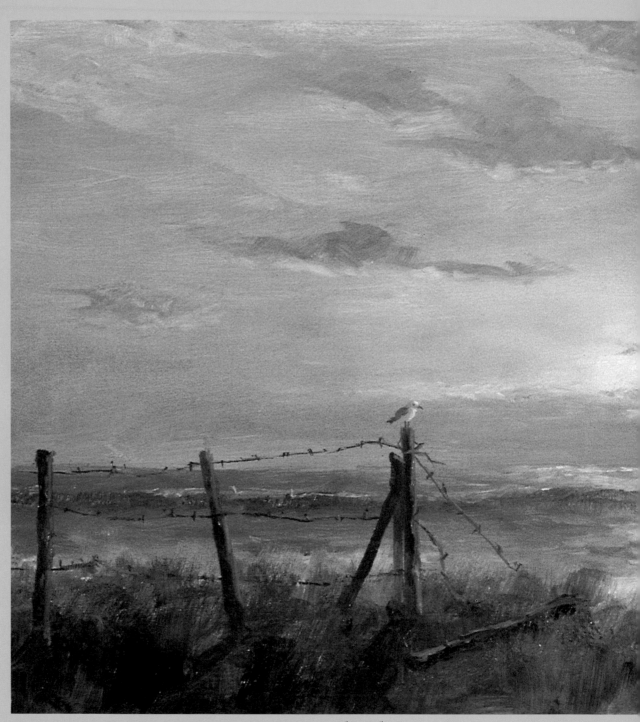

Gull at Sunset · Robert Wee · Water-soluble oil on canvas · 9" X 12" (23cm X 30cm)

chapter three

ARTISTS' THOUGHTS ON WATER-SOLUBLE OILS

I invited several artists to talk about their experiences with water-soluble oil color. Some of the artists have been using this new medium for a while, but most are experiencing it for the first time. The paint manufacturers generously provided paint sets for each artist to experiment with. Some artists have provided samples of work in their traditional mediums to compare with new paintings in water-soluble oil. This chapter records the observations and reactions of experienced artists as they explore water-soluble oil color.

Sean Dye

tips

✳ Mix your color well before adding water. Colors are slightly lighter when first mixed with water but return to the original value when the water evaporates.

✳ There's no need to own two sets of paints. Water-soluble oils can be mixed with traditional solvents to create solvent-derived washes.

✳ Keep an open mind. If you are currently using traditional oils, some experimentation will be necessary to replicate the experience using water-soluble oils. You should be able to nearly match your normal working process. There will likely be small differences in texture and movement of the pigment, but the benefits will outweigh the small adjustments.

cautions

✳ When the water-soluble oil is mixed with water, it may appear somewhat cloudy until the water evaporates.

✳ Some artists initially find the paint to be a bit sticky when painting with a brush. Adding a small amount of water-soluble linseed oil will solve this problem.

✳ The various brands have slightly different textures of paint. You should experiment to find which consistency works best for your method.

Use Medium With Paint
I mixed Winsor & Newton Artisan Fast Drying Medium with my paint. The mixture has the same consistency as the traditional oil mixed with the jellied medium.

When I considered using water-soluble oil colors, my first question was, how do they compare to traditional oil colors? I decided to make two paintings of a similar subject matter—Maine fishing boats—using traditional oil color for one and water-soluble oil color for the other. Both types of paints were made by Holbein.

Water-Soluble Oil vs. Traditional Oil

The support for *Early Catch*, done in water-soluble oil, is a commercially prepared gesso board by Ampersand. The surface is made by spraying gesso onto hardboard (Masonite). The result is a smooth painting surface that is free of brushstrokes and texture.

Sketch for Early Catch · Sean Dye · Egg tempera on canvas panel · 8" × 6" (20cm × 15cm)

Owl's Head Boats, the traditional oil painting, is painted on stretched canvas that has four coats of acrylic gesso. Each layer of gesso was sanded to provide a smooth surface for painting. Aside from the slight give of the stretched canvas, these surfaces are similar. Because the canvas has so many layers of sanded gesso, there is no longer a significant texture.

Sketching the Composition—For both of these paintings, I did my initial drawing with India ink on the white gesso. For *Early Catch*, I used a ½-inch (12mm) flat and nos. 8 and 10 round watercolor brushes. For the somewhat larger *Owl's*

Use Egg Tempera to Lay Out Your Canvas
I used egg tempera on canvas panel to lay out my painting and play with color. The egg tempera is quick drying and provides a dull, matte finish when fully dry. To build somewhat transparent layers, I add egg tempera medium to the paint.

Head Boats I used a combination of 1-inch (25mm) flat, ½-inch (12mm) flat and no.10 round to apply the ink. I prefer to use a long-handled natural/synthetic blend for watercolor brushes because they have better balance for easel painting. For both sketches I occasionally added ink to make changes in value. After the sketches were finished, I gave them a light spray of workable fixative. The India ink is labeled waterproof but not acrylic proof. This step is important because for both paintings I planned to do some underpainting washes with acrylic paint, which would smudge the ink if not for the fixative.

Underpainting—I used acrylic color for both underpaintings. Acrylic gesso is somewhat porous and is designed to absorb some of the oil paint. To ensure proper adhesion, acrylic used underneath oil color should only be applied in light washes so not to diminish the absorption of the gesso. I wanted both paintings to be primarily cool in color, so I used warm combinations of Alps Red, Cadmium Red Medium, Cadmium Yellow, Cadmium Yellow Light, Orange and Ultramarine Blue to achieve some violets and red-violets. By keeping these colors the same in both paintings, I felt that I would be able to compare the oil layers better.

Building Layers—For a traditionally layered painting, each layer should be thin. It is important to work fat-over-lean. For *Owl's Head Boats*, I thinned my oil paints with Turpenoid, which is a turpentine substitute. The washes used with this method are nearly impossible to duplicate with the water-soluble oil. However, fumes are generated when you spread the mixture of oil color and mineral spirits. I have a powerful overhead direct vent fan in my studio that moves air at a rate of eighty cfm (cubic feet per minute). This reduces the fumes dramatically, but it is impossible not to breathe in some harmful vapors unless you wear a respirator. Most good paint

Medium Increases Transparency and Shortens Drying Time

I used Holbein Duo Aqua Oils for this water scene. I added Winsor & Newton's Artisan Fast Drying Medium for water-mixable oils (alkyd based) to increase transparency and to shorten drying time.

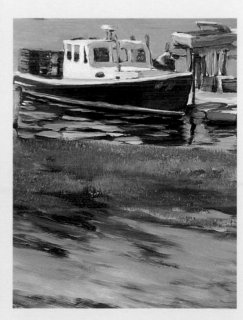

EARLY CATCH Detail

By adding medium to the paint, it is possible to achieve fine detail.

Early Catch · Sean Dye · Water-soluble oil on gesso board by Ampersand · 24" × 18" (61cm × 46cm)

stores sell suitable respirators, but they are not much fun to wear. I have met only one artist, a pastelist, who wore a respirator for her entire work week. With the water-soluble oil color, there is no need to thin with harmful solvents, because this can be done with water.

Sometimes the colors became slightly lighter when first mixed with water. However, as soon as the water evaporated, the colors returned to their original values. The trick here is to mix your color well before adding water. The major drawback is that the washes just don't have the same feeling as an oil/mineral spirit wash. Since I normally paint over much of my initial washes anyway, the improvement in safety is well worth this minor sacrifice. If you must have those very unique solvent-derived washes, there is no need to own two sets of oil paints. Water-soluble oils can be thinned with turpentine or mineral spirits, but they will lose water-solubility. With good ventilation in the early stages, the artist can then complete the painting by using the various water-soluble mediums for later layers.

Building Up Transparent Layers—To make my paint more transparent and to speed drying time in *Owl's Head Boats*, I used Holbein's Painting Medium Jelly, a mixture of petroleum oil, succatif and alkyd resin. It is similar to the popular Liquin alkyd medium by Winsor & Newton. I mixed the medium and paint in equal amounts. The medium makes the brush move more easily across the surface of the canvas.

For *Early Catch* I found Winsor & Newton's Artisan Fast Drying Medium for water-mixable oils (also alkyd based) to be very similar to the jellied medium only slightly less viscous. I was able to build thin layers of paint the same way that I did with the traditional oils. Unlike the wash stage, this experience was exactly like working with traditional oils.

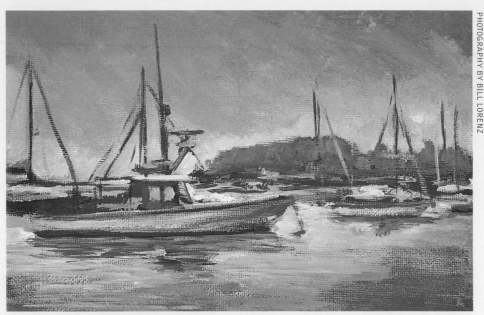

Use Casein for Small Studies

I made this small study using casein, which dries quickly to a matte finish. This study helped me keep my general color scheme in mind and helped me create a layout for my composition. I ended up using less violet in the final painting.

Sketch for Owl's Head Boats · Sean Dye · Casein on canvas panel · 6" × 8" (15cm × 20cm)

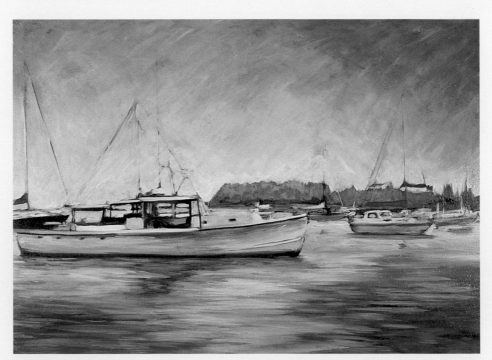

Compare Compositions

Sometimes it is interesting to see an earlier version of a completed painting. Notice the lack of contrast in the lights and darks here compared to the final painting.

Owl's Head Boats (early version) · Sean Dye · Traditional oil color on canvas · 30" × 40" (76cm × 102cm)

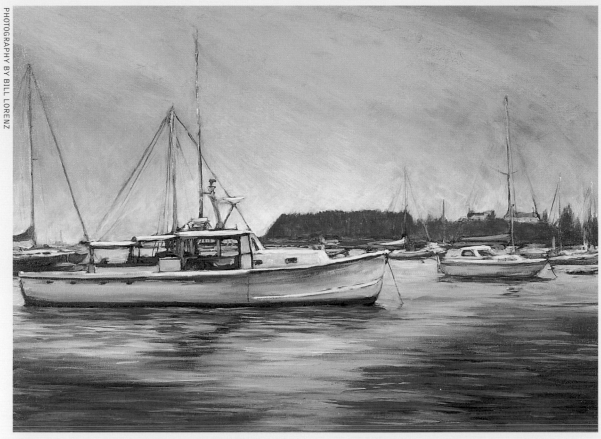

Owl's Head Boats · Sean Dye · Traditional oil color on canvas · 30" X 40" (76cm X 102cm)

Decrease the Drying Time of Traditional Oil Paint

I used traditional oil color for this painting of Maine fishing boats. I added Holbein's Jellied Painting Medium (alkyd based) to the paint to speed drying and increase transparency for a traditional layered effect.

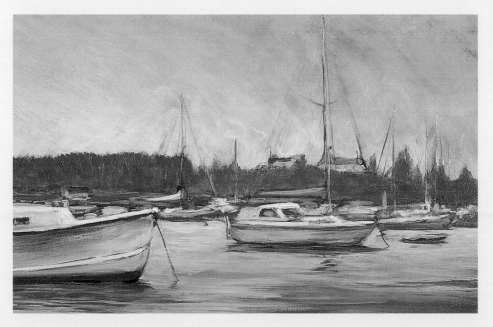

OWL'S HEAD BOATS Detail

By adding jellied medium to the paint, small detailed strokes and many layers of transparent paint can be created.

Create the Setting You Want

This barn was painted because of its weathered appearance and reminiscence of an earlier time in Vermont. It is easy to imagine this barn in a rural setting, but actually it sits next to a local grocery store in the heart of a busy village. Linen was used as a ground because of its beautiful texture.

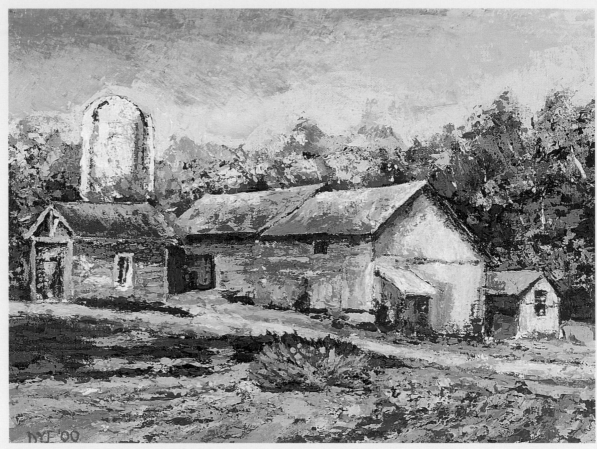

Hinesburg Barn · Sean Dye · Acrylic on linen · 18" X 24" (46cm X 61cm) · Collection of E. Peter Hopper

Water-Soluble Oil vs. Acrylic

Since many artists will come to water-soluble oil from an acrylic painting background, I thought it would be interesting to compare the two mediums. Both paintings are horizontal country landscapes and executed with painting knives only (no brushes). The only other variable, besides the medium, is that *Hinesburg Barn* is painted on linen, which is more heavily textured than the cotton duck canvas used for *White Mountain Pass.*

Initial Drawing and Underpainting—My initial drawing for both paintings was done with a mixture of Ultramarine Blue

and Burnt Sienna acrylic paint plus Golden's GAC 100 acrylic medium. The mixture is fluid yet fast drying. I find it is best to draw with no. 6 flat and no. 5 round hog bristle brushes. For the shadow areas I used a no.12 filbert brush. For both underpaintings, I used the acrylic in the analogous colors of red, red-orange, orange and yellow-orange. I worked very quickly in wet washes using a no.12 flat and no.12 filbert brush.

For *Hinesburg Barn* I used Holbein acrylic, which is characteristically softer than oil paint. I added a small amount of gel medium to my paint to add body. The gel medium also increases the transparency of the color in varying degrees

depending on the inherent transparencies of the given pigment. The increased transparency allows more light into the color and thus changes the quality of light reflected back. The resulting color is richer and interesting to look at. When I work with acrylic paint and the knife, timing is everything. Because acrylic dries quickly, organization is important. I only squeeze out as much paint as I need for about ten minutes of painting. The process of knife painting, which involves constant mixing, exposes the paint to more air than it would receive if it were merely sitting on the palette.

The major advantage to this fast drying medium is that I can put layer after

Paint What You See

Each summer I take several trips to Maine with my family. On the journey from Vermont to Maine, it is necessary to pass through the glorious White Mountains. I see these views on each trip. I decided to keep this painting loose and free using only larger painting knives.

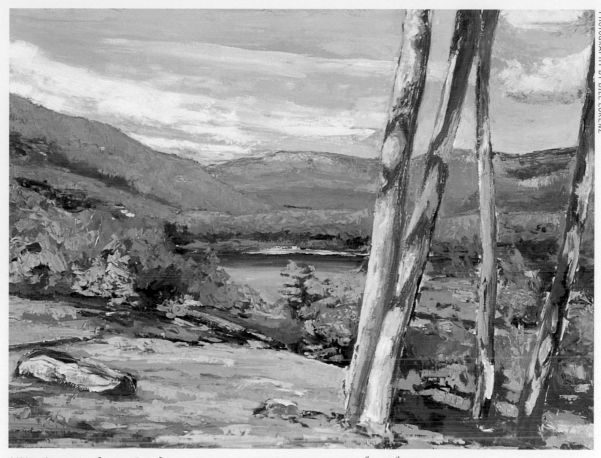

White Mountain Pass • Sean Dye • Water-soluble oil on canvas • 36" X 48" (91cm X 122cm)

layer of paint on the canvas almost as fast as I can mix it. If you analyze this painting, you will see the many layers involved in its creation.

I found knife painting for *White Mountain Pass* to be quite a different experience. First of all, I did not have the constant pressure to keep up with the drying of the paint. Once the paint is squeezed onto the palette it remains workable for a few days, especially when it is covered. I found that I wasted much less paint than with the acrylic because I rarely had to throw away dried paint. I knew that I would have to wait much longer between layers (sometimes as many as five days), so I decided

to work on a much larger canvas. This way I would be able to spend more time on each layer simply because there is more surface area to cover.

Having anywhere from two to seven days to coexist with a painting in between layers made me more critical during the early stages. I made notes during each drying hiatus. When it came time to paint again I would try to work with the same spontaneity and frame of mind as the previous layer.

Final Comparison of the Two Paintings—Even though I used highly pigmented acrylics for *Hinesburg Barn*, the color in *White Mountain Pass* seems

to truly sing. I suspect that this is due to the fact that the pigment vehicle is oil and not acrylic polymer. Having extra time to mix color and the ability to remove color was a huge advantage associated with the water-soluble oil.

When I knifepaint there is virtually no cleanup. I constantly remove color from the painting knives with paper towels or rags so there is nothing to wash up. I did not add any mediums to my water-soluble oil color, so the experience was identical to that of knife painting with traditional oil color.

Greg Albert

Greg Albert has painted in many different mediums—traditional oil, acrylic, alkyd and now water-soluble oil. He is predominantly a plein air painter who works alla prima, finishing his paintings in one sitting. Since 1996, he has been painting with water-soluble oils almost exclusively. He finds that the paint handles identically to traditional oil and is great for his loose, Impressionistic style.

The water-soluble paint has had no negative effects on his painting technique; if anything, it has enhanced it. Albert saves time by not having to painstakingly clean his brushes throughout the painting process. This allows him to maintain his concentration while painting.

The water-soluble oils have many favorable characteristics. It is easier to avoid mud—the dirty colors that accu-

Traditional Oil Painting
CARRIAGE HOUSE, SPRING GROVE and NEAR CHASE AND HAMILTON are very similar paintings. They both took about two hours to complete, used a similar palette and were painted in similar weather conditions. The only difference is the medium used to paint them.

Carriage House, Spring Grove · Greg Albert · Traditional oil · 20" × 16" (51cm × 41cm)

mulate on the palette. Albert likes the improved drying time of water-soluble oils. He finds that acrylics dry too fast and don't remain plastic enough to blend while painting. Traditional oils are messier and more difficult to clean up after a painting session. So the easy cleanup is, of course, a big plus. But best of all, they still smell like traditional oil paint.

Albert likes to find a nice quiet corner of the city and record the beauty of everyday life. When painting on location with water-soluble oils, Albert's supply list is brief: pigments, canvas, Pochade box, a few choice brushes, a bucket and a gallon of water. In his water bucket he keeps a wire brush cleaner. He finds this is a great method for cleaning his brushes while painting with water-soluble oils.

Once he returns home, a little soap removes any remaining pigment in his brushes. He finds it to be a great relief not to worry about transporting chemical solvents used with traditional oils. Not only is traveling simplified, so is disposal. No more containing the solvents and taking them to the recycling center.

Simplify Your Painting Process

Albert finds that he uses fewer brushes when painting with water-soluble oils. With traditional oils, he keeps several brushes in order to keep the brushes clean. He would use one for dark values and another for lighter ones. Water-soluble oils rinse cleanly from his brushes, so he is able to use the same brush throughout a painting session. Now he uses only two or three brushes instead of five or six.

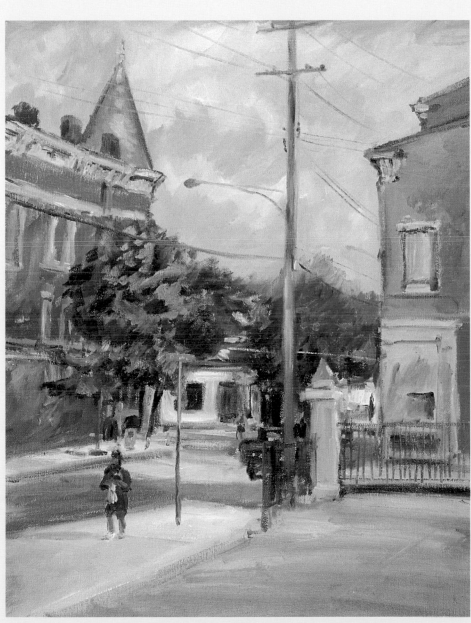

Near Chase and Hamilton · Greg Albert · Water-soluble oil · 20" x 16" (51cm x 41cm)

Paint Scenes From Everyday Life

Albert likes to capture the beauty found in everyday scenes, like this one in the neighborhood where he spent his childhood. He finds that water-soluble oils allow him to paint quickly, capturing the immediate impression he receives from the scene. He does not beautify his subjects; they don't need it, as the unfiltered image that is created is honest and beautiful.

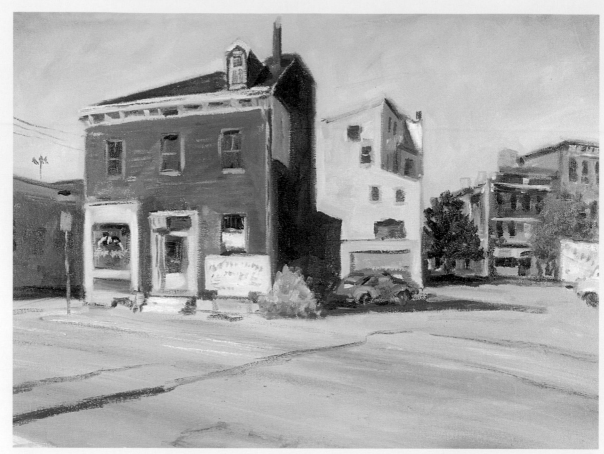

Near Knowlton's Corner · Greg Albert · Water-soluble oil · 16" X 20" (41cm X 51cm)

Paint Outdoors in Comfort

This painting was created on a hot summer's day in the comfort of the front seat of Albert's car in about one hour. The water-soluble oils allowed him to paint inside his car without the noxious fumes created by traditional solvents.

St. Catherine's, Westwood · Greg Albert · Water-soluble oil · 9" X 12" (23cm X 30cm)

Decrease Painting Time With Water-Soluble Oils

MT. ADAMS, STREET VIEW was painted inside Albert's car. It was late in the day with about only one hour of sunlight left. Due to the faster and more efficient working process that water-soluble oils has afforded him, Albert was able to complete the painting quickly.

Mt. Adams, Street View • Greg Albert • Water-soluble oil • 9" × 12" (23cm × 30cm)

Jeanette Chupack

When painting outdoors (en plein air), Jeanette Chupack's greatest problem with her usual medium, acrylics, is precisely that which she appreciates them for in the studio, the fast drying time. She started using watercolor for her plein air work and found it better to work with than acrylic, but she would prefer something more flexible that she can work over and into. With the water-soluble oils, she hoped that the drying time would allow her to work more comfortably and get more color and detail information than she can with watercolor. In addition, since most of the time she is working at the seacoast, the oils would allow her to work in fog and other moist conditions that are difficult with both acrylic and watercolor.

On a trip to Buzzard's Bay, Massachusetts, Chupack had the opportunity to try water-soluble oils in her preferred setting. She had already discovered that they worked best for her on gesso-coated watercolor paper using fast drying medium. For the painting *Incoming Tide*, she was working in foggy, wet conditions. She had no problems with running paint or drying times. When painting *Sunny Afternoon,* she started with an underpainting of light yellow-green, and worked wet-in-wet, finding that thin layers dried quickly enough to be painted over and heavier layers allowed for manipulation and blending.

Chupack was pleased that she could work larger and with greater ease than she could with watercolor. The ability to make changes in both color and layout is important to her when painting on location, so these oils certainly allowed her to do that. Working on the prepared paper with the fast drying medium, the paintings were dry enough to pack or stack on top of one another in about two days. Since she likes to complete a sketch in one sitting, she has not experimented with going back into the painting, but considering the drying time, it is certainly a possibility.

Gesso Protects Paper

Acrylic gesso is used to protect the paper before applying the water-soluble oil. The essence of the rising tide and foggy conditions were captured in one sitting.

Incoming Tide · Jeanette Chupack · Water-soluble oil on gesso-coated Arches 300-lb. · (640gsm) watercolor paper · 11" × 15" (28cm × 38cm)

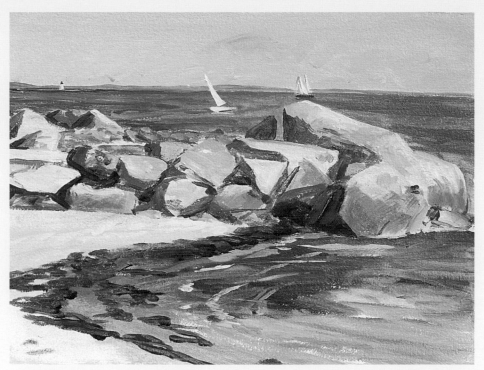

Use Watercolor With Water-Soluble Oils

Chupack used watercolor for this landscape because she feels it is easier than acrylic to use outside. The wind and sun dry the acrylic on the palette very quickly. Watercolor can be activated with water, so she doesn't worry about dryness. The problem with the watercolor is that she can't build layers the same way that she can with an opaque medium. The water-soluble oils stay wet longer, and she can use the layering that works best for her technique.

Sunny Afternoon · Jeanette Chupack · Watercolor and water-soluble oil on gesso-coated watercolor paper · 11" X 15" (28cm X 38cm)

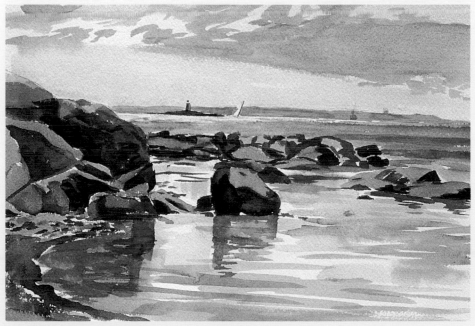

Watercolor Captures the Sunshine

Chupack captures the brilliance of sunshine in this watercolor. The light coming from the bright white watercolor paper adds to this effect. If she were to use similar colors with oil paint, the effect would be different because the paper needs to be protected with gesso.

Sunny Day: Buzzard's Bay · Jeanette Chupack · Watercolor on watercolor paper · 7" X 10" (18cm X 25cm)

George Teichmann

tip

You can produce the finest detail using the linseed oil that was created to thin the water-soluble oil paints.

George Teichmann is a wildlife artist, originally from Czechoslovakia. He resides and maintains his studio in the Canadian Yukon. He has enjoyed wildlife and the outdoors since childhood. He has a passion for paleontology and animals that have lived since the last ice age. He researches his subjects in detail before he begins to paint.

Teichmann has been a dedicated water-soluble-oil painter since 1996. He lives in close proximity to his work and therefore likes the easier soap-and-water cleanup and the elimination of the toxic fumes of thinners. He paints mostly in a traditional manner with the exception of a few techniques, like using primed foamboard and an acrylic primary painting to quickly enforce line, form and basic color. His paintings take a lot of time to prepare for as well as to make.

He only paints in the daylight when working with oils. He paints in many thin layers, using water and linseed oil. He works on about three or four pieces at the same time. He works flat, rather than on a wall or easel, to achieve detail. A 30" × 40" (76cm × 102cm) painting can take as long as two to three months to complete due to the extreme detail.

Teichmann refuses to compromise time and effort for quality and detail. When he first switched from traditional oil to water-soluble oil color, he had to figure out how to make the appropriate changes in his work habits to maintain his highly detailed style. He now feels that the water-soluble oils are ideal and he can paint anything with the water-soluble oil that he could paint with traditional oil.

Use Brushstroking to Create Realism
BUTTERFLY AMBUSH captures the calm before the storm and the inquisitive look of a tiger kitten ready to pounce. The vibrant purple in the iris serves as a frame to draw attention to the butterflies. The smooth texture achieved in the brushstroke creates a photo-realistic image.

Butterfly Ambush · George Teichmann · Water-soluble oil on canvas · 16" × 26" (41cm × 66cm)

Traditional Oil Example

This exciting image captures both a scenic land-scape as well as amazing wildlife. Teichmann uses a traditional triangular composition but decided to use major foreshortening in the bear. The atmospheric space cast in the painting truly makes the mountains seem like towering peaks of the Yukon.

Beauty'n the Beast • George Teichmann • Traditional oil on canvas.
24" X 20" (61cm X 51cm)

Water-Soluble Oils can Capture Details

The short-snouted bear is painted with meticulous detail. The paint goes on with deliberate intention, showing how each hair on the bear moves in the breeze. We are able to witness this amazing animal as it moves through the forest. The light is cast beautifully on the subject and suggests an overcast afternoon in autumn.

Pre-Historic Giant Short-Faced Bear • George Teichmann • Water-soluble oil on canvas •
24" X 45" (61cm X 114cm)

Robert Wee

tip

The paint is a bit stiffer when mixed with water. If you don't like this, all you have to do is use the water-mixable oil painting medium or the water-soluble linseed oil.

caution

When using water-soluble oils be careful they don't gum up your brush. To offset this problem, I put detergent and water in a can and set it next to my clean water. When the brush starts to gum up, I swish it through the detergent water and then rinse it in the clean water. This seems to help keep the brushes clean. If it gets too bad, I wash the brush with soap and water. The paint cleans out fast and the brush is ready to go. It is nice to be able to use the brush immediately without waiting for it to dry.

When Robert Wee first began to paint with water-soluble oils, he was apprehensive to say the least. It just didn't seem natural to dip a brush into water and then into oil paint. He didn't think he was going to like it. In the beginning, the paint seemed stiffer and harder to manipulate. However, after painting with it for a few minutes, this didn't prove to be true. Wetting his brush with the water-soluble linseed oil proved there was no difference at all.

"I can do anything with this medium that I can do with regular oil paint," Wee states. As a matter of fact, he says he has really grown to like it. The colors mix and blend well, just like traditional oils. They also seem to have a brighter quality to them. "I can't put my finger on it," he says. "I only know that when I compare a finished painting in this medium with one of my traditional oils, the one in the water-based medium seems to have a brighter quality to it." Other than this he can find little difference between the two mediums. As far as cleanup is concerned, Wee says it is certainly easier to clean his brushes after a day's work with the water-based medium.

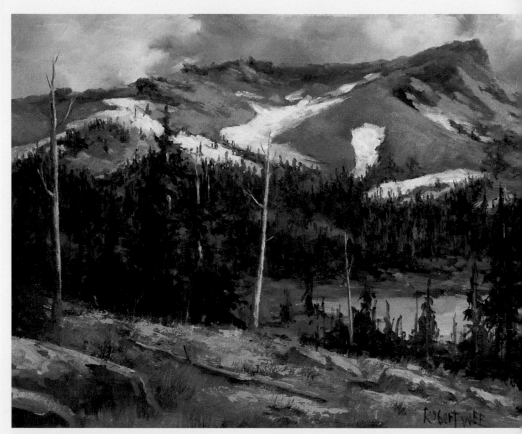

Paint Patterns of Snow
This painting shows the remnants of snow on Thimble Peak in Carson Pass late in the spring. The snow patterns left on the mountain are what attracted Wee. This setting is along Highway 88 in the California Sierras. The peak was farther off in the distance than the foreground would indicate. The foreground has some interesting brushwork and flicks of the palette knife.

Snow Remnants (Carson Pass) · Robert Wee · Traditional oil on panel · 11" × 14" (28cm × 36cm)

Water-Soluble Oils Produce Fresh, Strong Color

This sketch of Wee's backyard was painted on a sunny winter day. His home is in the California Sierra Mountains at about the four-thousand-foot level where there are several snowstorms each winter. He decided the sketch would make a good subject for a finished painting using the new water-soluble medium. The focal point is the lower right side of the painting where the sunlight is striking the snow. Wee states that every painting he does in water-soluble oils comes out with the colors looking strong and fresh.

Sunlight Snow · Robert Wee ·
Water-soluble oil on panel · 11" X 14"
(28cm X 36cm)

First Attempt at Water-Soluble Oils

Wee says this was his first attempt at using water-soluble oil colors. He wanted to keep the painting fairly small and simple until he got a feel for the paint. The painting is a fairly simple one with the focal point being the crashing of the wave. The flying gull was added as a second point of interest, and from there your eye is drawn to the strong light in the sky.

Surf on the Rocks · Robert Wee · Water-soluble oil on panel. · 14" X 18" (36cm X 46cm)

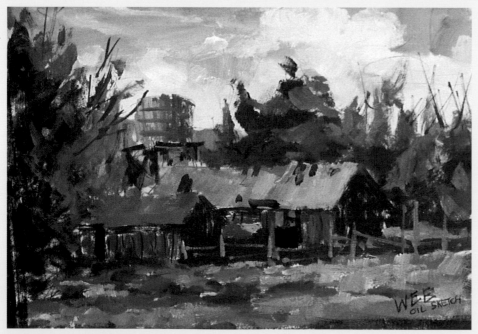

Two Together · Robert Wee · Water-soluble oil on board · 5" X 7" (13cm X 18cm)

Water-Soluble Oils Are Great for Plein Air Painting

This is a small field sketch Wee figured he would use for a larger piece. It was started with a pencil sketch roughing in the large shapes. The water tower was added to the composition. It wasn't located behind the two sheds but was in the general area. When the painting was finished, it had a fresh spontaneous quality. A fast sketch is often more interesting than a finished piece. The nice thing about water-soluble oils on location is you don't have to drag along paint thinner and you can easily dispose of the water.

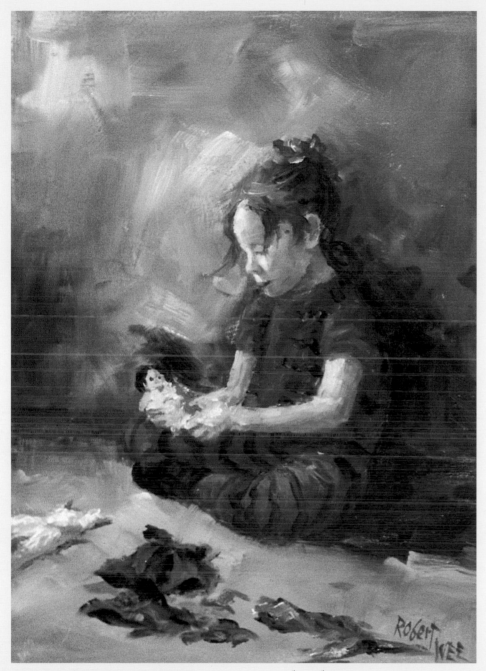

Amanda · Robert Wee · Traditional oil on panel · 12" X 9" (30cm X 23cm)

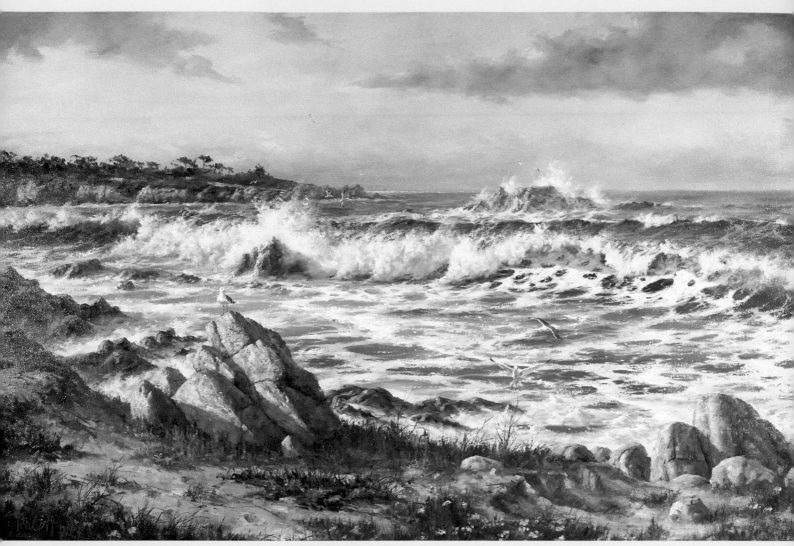

Create Breathtaking Waves

This painting of Seventeen-Mile Drive on the Carmel coast, near Pebble Beach Golf Course, is part of Wee's permanent collection. The breaking wave is the focal point, with another wave crashing over the rock formation in the distance as a secondary point of interest. There are gulls strategically placed throughout the composition. One can almost feel the spray coming off the breaking wave.

Carmel Coast · Robert Wee · Water-soluble oil on linen · 32" × 50" (81cm × 127cm) · Collection of the artist

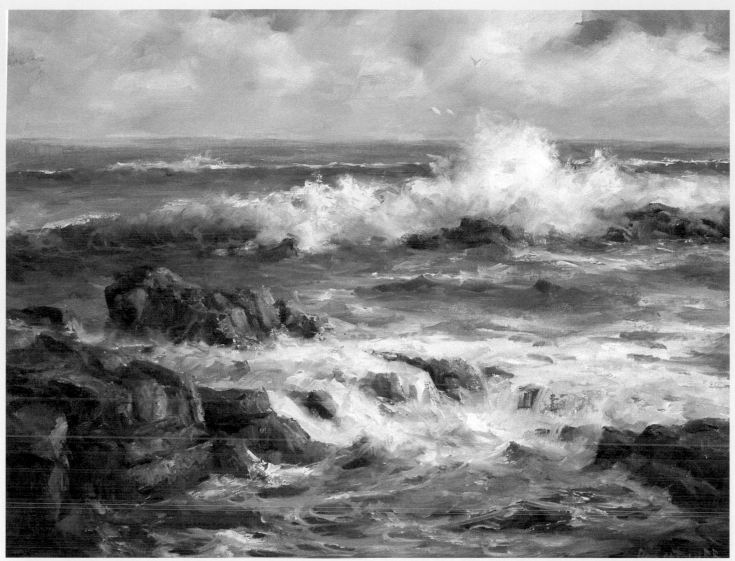

Paint Moving Water

During the past forty-five years Wee has lived on the West Coast and gotten the reputation of being a painter of the sea. He likes the fresh, bright feeling of this painting. It is loose and free as a seascape should be. Water is a moving thing; you don't get that feeling in a tight detailed painting. People say they can almost feel the spray and the moving water. For some reason Wee finds it easier to get this feeling and movement with water-soluble oils. Maybe it is the consistency of the paint. It seems to have a lot of pigment and great covering power. He likes the feel of it when he applies it to a canvas or panel.

Last August Wee and his wife took a three-week tour of the East Coast. He found the rock formations on the Maine coast of special interest. They are so different from the California coast. He took a lot of pictures for future reference. Some of the pictures were used in the foreground on this painting.

Wave Off a Rocky Shore · Robert Wee · Water-soluble oil on panel 14" × 18" (36cm × 46cm)

Lynda Reeves McIntyre

tip

Be sure to test the interpretation of color and transparency, or cloudiness, as they are unique to this medium.

Lynda Reeves McIntyre worked with oil color until 1969 when she made the switch to water-based media upon discovering that she was allergic to the solvents used for traditional oil color. The advent of an oil paint that was water-based was exciting to McIntyre, as she prefers to work her pigments for an extended period of time. She used a number of different brands of water-based oils to explore their capacity to replicate recent works she has been doing with acrylic and watercolors. The paintings she created are rather aggressive in terms of color, and she is unsure whether the bold sense of color is inherent in the paints or in the artists who paint with them.

McIntyre began by painting some still-life pieces using many layers of subtle transparent washes. She admits that her first attempts were muddy. The paints seemed to become cloudy in a wet state. After experimenting, she was able to gauge the amount of water, timing and transparency needed to produce a clean, clear and radiant, but not too pure, color.

Create Texture Using Water-Soluble Oils

Texture is a main component of this piece. The oranges do not appear to have been worked with oil color, but look more like wet-in-wet watercolor. The cool background colors and sense of shadow in the front of the piece make the orange come forward, creating a sense of depth.

Oranges in Aqua Porcelain • Lynda Reeves McIntyre • Water-soluble oil on canvas panel • 6" X 8" (15cm X 20cm)

Acrylic Creates Texture

The oranges in this piece are all about texture. While there is a slight sense of volume in chiaroscuro, the fruit looks very tangible. The composition of this piece is also interesting with the offset of the leaves and the edge of the bowl that they rest in. The cool background blue complements the warm colors in the foreground.

Italian Oranges • Lynda Reeves McIntyre • Acrylic on canvas panel • 6" X 8" (15cm X 20cm)

When McIntyre used the water-soluble oils for more vivid landscapes, she found them exceptionally clear. They gave wonderful coverage with the ability to rework areas over time. On her more aggressive arid landscapes, the paints had a body and directness that was powerful without being too pure. She does not like the paints when artists use them so purely that they become garish—like a base color photocopy with heightened colors. This may be the function of the painter's choice or inexperience combined with the intense color of the paints. Like any new medium, the water-soluble oil paints take time to get to know and combine with the technique of the artist.

Oranges in Aqua Porcelain was painted over five days. Using gessoed canvas, McIntyre worked a very transparent wash of dabbled water-soluble oils to begin building up the orange forms. She found that she would work for two to four hours and eventually get a transparency that seemed appropriate. She allowed the first layer to set for a day. McIntyre worked transparently for each successive layer keeping a sense of radiance and tactile quality to the forms.

She used the same layer-on-layer approach on the plate. This was a challenge at first because the colors tended to look cloudy when wet, but would dry clear. If she worked them as vibrantly as she wanted the final color, they eventually looked too solid and heavy, without the quality of dappled light she was trying to achieve. Learning the appropriate mix took time.

The landscapes were also worked on a gessoed ground. McIntyre works both on canvas and paper. She often prefers paper for the liveliness of color, but with these paints both grounds work well. For her approach to painting, the paints need to have a gessoed ground to work well. With the more aggressive landscapes, she was able to lay down a first wash of color and then build up quite quickly. She could overpaint, layer, dissolve into a color and develop soft or hard edges with ease. On the more washy works, she worked totally transparently and was able to work on a non-gessoed surface. She needed to let the areas become almost completely dry before abutting another color. As with oils or acrylics, the papers transfer the liquids. On those works where the image had more boldness and more body, she could quickly build up many layers of color and then dissolve or scrape through the paint if she desired. Although she did not work in an impasto approach, she thinks the water-soluble paints would lend themselves to this heavy and textured approach.

McIntyre really enjoyed working with these paints, particularly outdoors. She is not sure whether she will be able to work with them in the studio. They have the hand of oil, can be reworked, allow for manipulation of color, texture and transparency over time. They clean up with ease and less toxicity than standard oils. They take some experimentation to really make them work.

The sad aspect of this experiment was the fact that she really began to understand and like the media but found that she was still irritated by the paints. She assumes now that she is not allergic to the turpentine but to the linseed oil.

Paint Interesting Color Schemes
A calming blue background surrounds the warm analogous colors in the mountains. McIntyre has created a beautiful depiction of the jagged edges of the mountains with a softer foreground, which tends to create a sense of depth.

Arid Hills Urlara • Lynda Reeves McIntyre • Water-soluble oil on gessoed cotton • 12" X 40" (30cm X 102cm)

Reed Prescott III

Reed Prescott was pleasantly surprised with his results when he painted with water-soluble oil paint. The luminous effect that he achieved in *Jen's Summer* felt to him as if the painting glowed. He found it was easier to keep the colors pure and clean. The use of water-soluble oils did take some adjustment. When Prescott starts with a fresh palette of traditional oil paints, he adds linseed oil to loosen up the paint, which is stiff when it comes out of the tube. He mixes linseed oil a drop at a time until the paint is the consistency of mayonnaise. If it needs thinning from there, he adds a glazing medium or thinner. Prescott observed that with the water-soluble oils, there is a delicate balance between adding to its base of oil and then thinning with water (the solvent for this medium). By loosening the paint with oil and thinning with water, the paint mixture becomes sticky as if painting with honey. Although the water-soluble linseed oil does clean with water, he finds that it was not "cut" as quickly as traditional oils are with turpentine. By increasing the oil in the paint, it seemed to decrease its ability to accept water. He found it difficult to achieve a good flow off the brush. It added drag to the brushstroke and gave a stippled, dry-brush effect. Thinning with medium lessened the dry-brush effect, but Prescott could not seem to achieve the flow he has grown comfortable with in traditional oil paints. The advantage to thinning with medium was that it made the paint more like a transparent glaze. This gave a luminous effect to the finished painting and the extra layering was worthwhile in the final result.

Traditional Oils Capture Light
In A BANK OF GOLD (traditional oil paint) capturing light was Prescott's goal. Oil glows in a way he has not found with other mediums. Traditional oils have always been able to capture the light he sought.

A Bank of Gold · Reed Prescott III · Traditional oil on canvas · 16" X 20" (41cm X 51cm)

Despite the adjustments that he needed to make to his method of working, Prescott finds the water-soluble oils to be a useful painting medium. He had to discover how the water-soluble oils could be applied in a way that best suited these new characteristics. Using a little less blending, more wet-on-wet painting, and more layering of paint, he was able to create the sense of light that is the focus of his work. According to Prescott, it is important to remember that your work or style evolves from the choices you make. An effect that he focuses on in his work might not be a goal in yours. When you paint, let your style evolve just by painting. Identify the effect that enhances your style and see how the water-soluble oil paint may be able to achieve that effect for you. Those who have had limited experience with traditional oils might adjust to the water-soluble oils more quickly. You might be more successful if you think of it as a brand-new medium altogether.

An important part of the painting process for Prescott is color mixing. He works to keep the colors clean and bright by not overmixing or mixing too many primary colors together. A yellow that leans toward orange when mixed with most blues creates a dirty green. Just a little bit of the primary red within the yellow can cause headaches. Over the years he has grown accustomed to his palette colors. Mixing adjustments should be expected whenever you add new variables to your palette.

Although he has tried several brands of water-soluble oil paint, Prescott found the easiest transition to color mixing by staying with the brand he was most familiar with. His advice for those that are relatively new to color mixing is to pick one brand and stay with it. If you are finding it hard to achieve the colors you desire, look for the hidden third primary in a color before switching brands. Perhaps you need to buy a yellow, blue or red that is truer instead of a completely new palette of colors. If you feel the need to switch brands, base that decision on how the paint handles when applied to the painting surface. Brands vary in characteristics, so choose the brand that best suits your personal painting style. A thicker, stiff paint might work very well for painting with palette knives but may not be as suitable for finely detailed painting. Think about the work first; everything else from brushstroke to color mixing should enhance the work.

Water-Soluble Oils Capture Light

JEN'S SUMMER captures the light source Prescott wanted. The struggle he had with detail was worth the price in order to capture the light. Understanding the medium well enough to achieve the detail he is used to with traditional oils was not as important and could still evolve as he uses the water-soluble oil paint more. The water-soluble oil paints reached and exceeded that level of light Prescott wants within a painting.

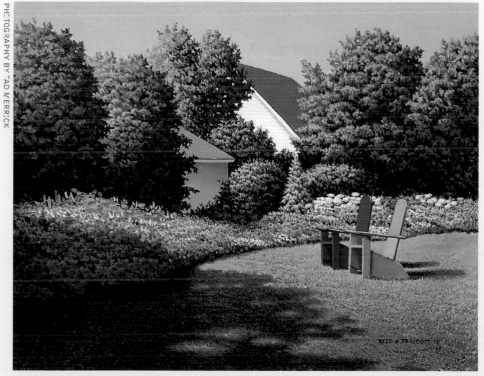

Jen's Summer · Reed Prescott III · Water-soluble oil on canvas · 16" X 20" (41cm X 51cm)

Don Bruner

tips

Here are some tips on brushes that can be used with water-soluble oil paint.

※ There are no harsh solvents involved in painting or cleanup with water-soluble oils, therefore, a variety of brushes can be used.

※ For underpainting, use medium to large hog bristle brushes—brights or flats. The stiffness keeps the paint layer thin.

※ Keep a clean flat or bright hog bristle brush to pick up color that has been applied too thickly.

※ Instead of expensive sables for fine work, substitute synthetic filament watercolor brushes or sable/synthetic blends. They hold the color well and are stiffer than pure sable.

※ For soft blending of large areas use either a large fan brush or big squirrel hair mop.

※ Keep an old worn out 2-inch (50mm) watercolor skywash brush handy to move paint around.

Don Bruner uses Winsor & Newton's Artisan Water Mixable Oil paints and mediums. He has found them to be very stiff out of the tube and to have a moderate level of gloss when dry. This works best when knife painting. The level of pigmentation across the Artisan line is very good, and there are a number of transparent or semitransparent colors. For thin layer work, the addition of medium is a must. He suggests a mixture of 70 percent paint, 20 percent medium and 10 percent water as a starting point for thin applications of paint.

Bruner has found that water-soluble oils work well with his painting process. He likes to begin a painting with a light charcoal sketch directly on the primed

Gastown-Vancouver • Don Bruner • Water-soluble oil on canvas board • 10" X 14" (25cm X 36 cm) • Collection of the artist

Experiment With Complementary Underpaintings

Experiment with color by completing a reverse color painting in complements of the intended local color first, using thinned oils or an acrylic wash. Under the greens of the foliage, you can see bright red. Under the oranges of the bricks is a bright jewel-toned blue.

When this acrylic layer was still wet, some lighter tones of acrylic were quickly brushed in to give some soft structure to the underpainting. This is still evident in the area behind the walking figures.

This painting called for careful control of the paint consistency. All the initial brushwork was quite thin with only a few touches of thicker paint here and there for emphasis.

canvas. Next he applies the underpainting, being careful to thinly work out the paint in a circular motion for better coverage. He changes colors and tones as he works so that all the major compositional elements are represented. Sometimes Bruner will compose with gestural brushstrokes of a darker color, working it directly into the underpainting. He allows this to dry for a couple of days.

Next Bruner paints the main subject, making note of the colors so he can incorporate them into the foreground and background later. At this stage he uses only thin applications of color using water-soluble oil painting medium. This allows him the flexibility to use thicker impasto later in the painting.

Bruner then considers the foreground and background. Since the main subject is established, he can adjust color, tone and brushwork to keep the focus on the subject. He likes to lead the eye through the finished painting by controlling the surface finish, leaving a duller, lean paint film in the darker areas and using a glossy, fat finish in the highlights. The final effect under gallery illumination is very dramatic.

Finally after the oil painting is dry to the touch, he evaluates the work to consider if it is complete. He may choose to use glazes to modify color or tone, or may add an area of impasto to create texture. Or he may decide the work is finished.

Underpaintings Create Color Variations

Try using a dark underpainting (acrylic or thinned water-soluble oils) and pre-plan some color variation. In this example Bruner used a black color where he wanted the figure and land to be and a very dark blue jewel tone where he knew the sky and water would be. Winsor & Newton Finity Artists' Acrylic Mars Black and Phthalo Blue (red shade) were used for this painting.

When he needs to mute a color Bruner does so by adding it's approximate complement from one of the colors he has already used in the painting. This helps keep color continuity in the work.

Kathryn at Parry Sound · Don Bruner · Water-soluble oil on canvas board · 8" × 10" (20cm × 25cm) · Collection of the artist

Vary the Opacity of Water-Soluble Oils

Water-soluble oils can be either fully opaque, semi-opaque or transparent just like traditional oils. In this painting the transparent properties of colors like Sap Green and Viridian were used to allow the black underpainting to deepen the values where they were thinly applied. On the other hand, the Cadmium Yellows and oranges pop out because they are opaque and cover the black. The Titanium White used in the light gray of the road and the blue of the sky has the same opaque qualities.

Fence Line · Don Bruner · Water-soluble oil on Masonite · 8" X 10" (20cm X 25cm) Collection of the artist

color charts

When Bruner began painting in water-soluble oils, the first thing he did was grab a 12" × 24" (30cm × 61cm) canvas board and lay out twelve colors down one side that looked promising. He spent about an hour filling up the panel in a checkerboard pattern with mixes of each color and all eleven of it's counterparts in body color and tinted 50 percent with Titanium White and then shaded with 25 percent black. That was two years ago, and the homemade color chart still sits beside his easel as a quick reference in case he needs to come up with something special. Every time Bruner adds a new color to his palette, he makes a test panel to see how it mixes with his favorites. This small investment of time really pays off when trying to remember how to get a particular effect in a previous work.

Use Pure White Carefully and Selectively

Often what you see as white is actually quite dark in value. Consider using slightly darker tones of blue or violet with gray instead and save the dazzling white for your focal point.

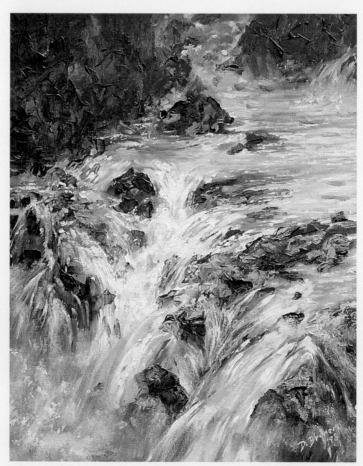

Waterfall Fantasy · Don Bruner · Water-soluble oil on canvas board · 16" X 20" (41cm X 51cm) · Collection of the artist

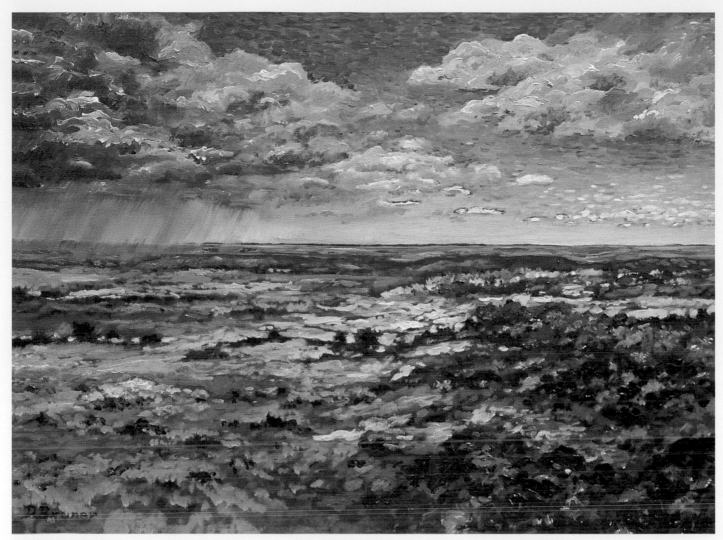

Painting Alla Prima

Doing a complete painting in one sitting may seem difficult, but it can be a lot of fun. Reference sketches, on-site photographs and two small 8" x 10" (20cm x 25cm) oil studies were arranged near the easel for quick reference. Keeping your colors separated on the painting as much as possible and working on a toned canvas will accelerate the process.

Using water-soluble oils means cleanups are quick and easy. This is a real advantage for maintaining clean brushes and palettes. Keep a rinse bucket full of water, a roll of paper towels, a small dish of brush soap and a big garbage pail beside the easel.

View From Mono Cliffs · Don Bruner · Water-soluble oil on canvas · 18" X 24" (46cm X 61cm) · Collection of the artist

about glazing

To create a glaze using water-soluble oils, use a medium like Winsor & Newton's Artisan Painting Medium, or water-mixable linseed oil. Either of these will make the paint thin enough to achieve a veil-like glaze of color while keeping the paint film tough and resilient. Using too much water to dilute the paint creates a chalky, unstable layer in your painting. Add the medium to the paint on your palette and mix it well with a palette knife before loading your brush.

Your semitransparent glazes must be rich in medium so they maintain the flexibility of the paint film. Using a lean mix over a dried layer could result in cracking of the applied glaze later. Colors that work well as glazes are the light sienna earth colors and transparent colors like Sap Green, Alizarin Crimson and the Phthalo Greens and Blues. Try adding Zinc White to make them semitransparent or Titanium White to create a more opaque, misty veil-like effect.

Linda Bruner

Linda Bruner likes to experiment from time to time with Golden Acrylic Heavy Molding Paste to create a sculptural feel in her work. She has been able to create a suitable ground for painting with water-soluble oils. She lightly sands a Masonite board and applies a coat of acrylic gesso. When dry, she applies lines of texture with a disposable medical syringe filled with molding paste, reshaping certain areas with painting knives. You can see this most clearly in the tree trunks, branches and roots.

Use Layering to Create Depth

In this work, Winsor & Newton Artisan Water Mixable Oils were thinned with either Artisan Painting Medium or Artisan Fast Drying Medium so that very thin layers could be applied. Using this layering technique gives a smaller painting great depth.

Once the molding paste has dried (one to two days), she ends up with a surface that resembles a relief carving. She applies a thinned coat of acrylic color as a final sealer. Then she is ready to begin painting.

Bruner recommends the heavy molding paste if painting on Masonite. If trying this on stretched canvas, it is better to use the more flexible light molding paste. Both types are available at most art supply centers.

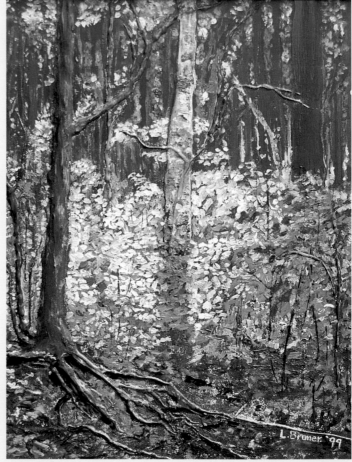

Off the Trail · Linda Bruner · Water-soluble oil over acrylic-textured board · 10" × 8" (25cm × 20cm) · Collection of the artist

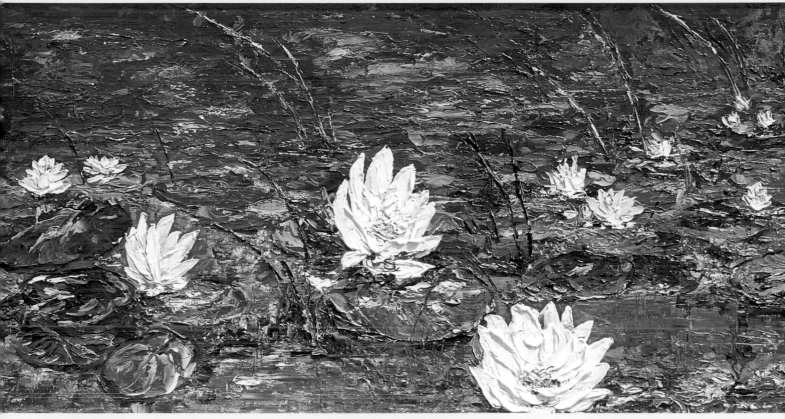

Use a Knife to Create Texture

The areas where standing water appears through the mat of leaves were painted thinly with downward strokes of the painting knife in mixtures of gray and purple. These areas were blended gently with a soft brush, followed by some vertical scraping through to the underpainting with a stiff knife to indicate reflections. After this dried, the lily flowers were added with the knife.

Water Lilies · Linda Bruner · Water-soluble oil on canvas board 12." X 24" (30cm X 61cm) · Collection of Mr. and Mrs. R. Keel

palette knives

Most high-quality palette, or painting, knives are designed for flexibility, but the steel used does rust if exposed to water. This is not a problem while painting, but rust will occur during cleanup. If using water, or a damp cloth, to clean your knives, be sure to remove all moisture with a dry paper towel before putting them away. Use a cloth dipped in a bit of linseed oil and give the knives a light wipe to prohibit oxidation.

cleanup

Use a commercially prepared brush soap and tap water to clean and condition your brushes. The soap gets into the base of the brush quickly and removes paint near the ferrule. Rinse the brush in lukewarm running water to remove the soap, and repeat until no more color comes out of the brush. Place the brushes bristle end up in a jar until they are dry.

Caroline Jasper

For Caroline Jasper, oil paint is the preferred medium. She was convinced that no other medium could match its feel, versatility and brilliance. Despite curiosity about water-soluble oil paints since first hearing of their existence, skepticism kept her from giving them a try. Having experimented previously in her career, Jasper found nothing to compare with the sensual qualities of traditional oil paint.

Jasper is not attracted to traditional water-based media for a number of reasons. In general, she finds watercolors unforgiving and inflexible compared to oils. Watercolor's inherent transparency prescribes working from light to dark on white paper. Layering paint to achieve opacity produces unwanted darkness or excessive brightness. And paintings can-not be revamped. As for acrylics, Jasper feels that, while they may be worked either transparently or opaquely, they dry too quickly, the paint consistency is inferior and the hues and values change when dry.

In spite of noxious solvents associated with oil paints (less toxic, less offensive replacements now marketed are less effective), Jasper favors oil paint for its malleability, color vibrancy and buttery viscosity. Her trials with new water-soluble oils from two different manufacturers—Duo Aqua Oil from Holbein and Max Artists' Oil Color by Grumbacher—forced some adjustments in her opinions.

Having the strong conviction that "nothing feels or looks as good as painting with oils," Jasper now admits that the new water-soluble oils "nearly duplicate" the smooth spreading, responsive touch of traditional oils brushed onto canvas. Whether they are squeezed from the tube onto a palette or painted directly on canvas, they are essentially the same as traditional oils. She feels that the application and coverage are consistent with traditional oils. The differences are subtle.

Jasper found little use for the water-soluble linseed oil because she found water-soluble oils to be slightly less opaque than traditional oil paints when considering both inherently opaque and inherently transparent colors. Minor adjustments were required. She applied more loaded brushstrokes than normal and applied more color after the underpainting hardened a bit.

Jasper was pleased to discover that the water-soluble oils did not dry while she was working. She was surprised to find that painted surfaces were still wet to the touch several days after she painted. While water-soluble paints dry more quickly than traditional oils, they dry much more slowly than any standard water-based media.

Traditional Oils Reflect the Artist's Style

This is an example of Jasper's work in her favorite medium, traditional oils. The light is cast through the trees beautifully. She finds the oil paints to be forgiving and flexible to her painterly style. For her the vibrancy of colors could not be found in any other medium until she found the water-soluble oils.

Rising · Caroline Jasper · Traditional oil on canvas · 40" X 30" (102cm X 76cm)

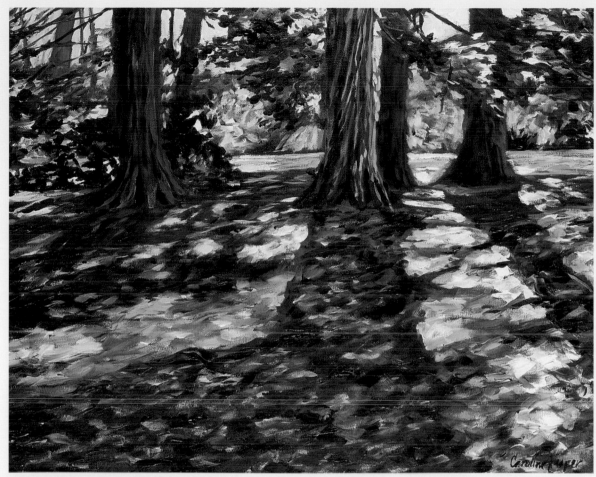

Anticipation · Caroline Jasper · Water-soluble oil on canvas · 16" X 20" (41cm X 51cm)

Jasper recognizes a temporary drawback in the appearance of water-soluble paint. She finds that even while wet, water-soluble oils lack the glossy appearance of standard oil paint. Final varnishing provides a simple solution to replicate the finish of traditional oils. She is quick to point out that unlike acrylics, the color characteristics are the same dry as when wet.

Regarding paint consistency, mixing and application, Jasper found the two brands she tested to be much the same. In comparing color quality, she noted distinct differences. Holbein's water-soluble Duo Aqua Oil colors have the same brilliance and color saturation consistent with Holbein's professional quality oil

paints. Duo Aqua Oil color name choices differ somewhat, due to Holbein's exclusion of cadmium. However, Duo Aqua Oil's broad variety of color options provides for reasonable substitutes for some missing traditional oil-based color favorites. She feels that color quality in the Grumbacher Max Artists' Oil paints falls more into the student-grade level rather than professional quality. Jasper's first Max Oils disappointment was with Cerulean Blue, a mainstay on her palette. It is a frequent contributor in mixing greens. Grumbacher's Cerulean Blue could not deliver the brilliant intensity she counts on for visual interaction with the bright red ground on which she begins all of her paintings. Less satura-

tion reduction was noticed in other Max Oils she used. However, Sap Green, Cadmium-Barium Yellow and Cadmium-Barium Red Light offered better color performance.

The greatest advantage with the new water-soluble oils is the easy cleanup; no more turpentine or other smelly solvents. Made-for-water-soluble-oil brush cleaners do most of the job. However, soap and water is still required for a thorough cleaning and can handle all the cleanup responsibilities.

The development of water-soluble oils responds to the age-old drawbacks of traditional oil paint. Jasper concludes that while the new paints were not an improvement on traditional oils, their

Light Provides the Basis for a Painting

Locating light provides a foundation for the rest of the painting. Everything else revolves around it, relates to it. The harsh impact of white, in contrast against the red, gradually becomes camouflaged as other colors, values and patterns are added. Using the water-soluble oils in opaque terms helps to keep spontaneity. She was better able to decide which color to paint where and then paint and leave it.

Moor Dreams · Caroline Jasper · Water-soluble oil · 20" X 16" (51cm X 41cm)

alteration of oil colors offers greater convenience and increased accessibility, especially to younger painters and those who have avoided oils simply because of cleaning solvents. Water-soluble oils also provide additional options for professional artists.

Jasper painted *Moor Dreams* and *Light as Water* simultaneously. She began them on the same day and con-

tinued to work back and forth between the two. One palette contained most colors for both.

The water-soluble oils took some getting used to, but some minor adjustments in working methods proved helpful for these water-soluble oil paintings. Jasper prefers working with opaque paint and wants full coverage in one application when laying down her

underpainting. When working with water-soluble oils in the past, she has found it difficult to achieve opacity without layering paint applications. Although the paint dries quickly, she does not want to repaint an area. Jasper only repaints areas to add another color or technique. She felt that with water-soluble oils, having to repaint the first layer to achieve the opacity she wanted mud-

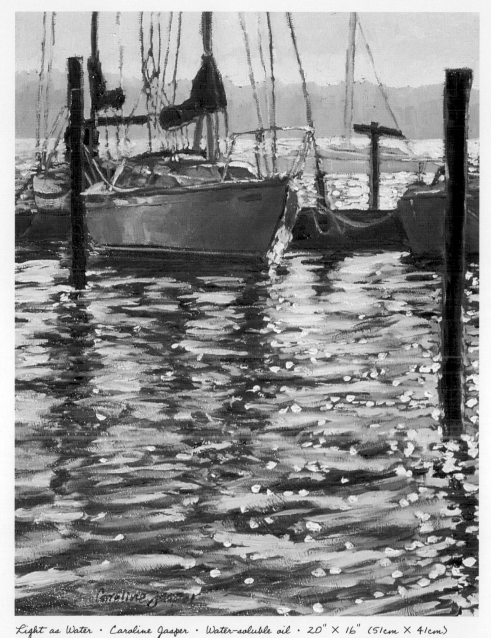

Light as Water · Caroline Jasper · Water-soluble oil · 20" X 16" (51cm X 41cm)

Glazing With Water-Soluble Oils is Faster Than With Traditional Oils

Transparent methods, similar to those used with standard oils, work much the same as with water-soluble oils. Glazing to alter color for the purpose of adding detail, developing character or enhancing depth may be accomplished with either medium. Sometimes, working wet-into-wet is preferred. Often, however, the next paint application requires waiting for the paint on the canvas to harden enough to remain undisturbed when adding paint. Since glazing cannot be accomplished until the underlying paint is dry, water-soluble oils have a great advantage. Waiting overnight, a day or two days is more pleasing to an impatient painter. Unless working alla prima, many more days of waiting between painting sessions are required for standard oils. One can accomplish greater progress in much less time when using water-soluble oils.

dled the results of her initial thinking. She changed her approach a little for these two paintings.

Jasper was dissatisfied with her use of the linseed oil medium made for the water-soluble paints. With standard oil paints, adding a little medium extends the paint, making it more spreadable without making it transparent. Adding medium to water-soluble oils made the paint too thin and transparent. Thinning with water insured transparency. Water-soluble oils, with or without medium, are drier than standard oils. That is, a brush loaded with standard oil paint goes much farther on the canvas than if loaded with water-soluble oils. They simply do not spread as well or as far as standard oils. This factor is not discernible in the finished painting, only in the process of painting.

To overcome the physical differences of the water-soluble paints, Jasper decided to work without using medium or water to thin the paint and was more satisfied. She went back to the palette for paint more frequently than when using standard oil paints but got better coverage and the opacity she wanted.

Robert Huntoon

Admittedly skeptical about the effectiveness of this medium, Robert Huntoon was pleasantly surprised to find that water-soluble oils compared quite favorably to traditional oils. Of most importance to him was the paint's ability to successfully convey a sense of atmospheric depth through his preferred oil painting technique—the layering of translucent colors.

For over twenty-five years, Huntoon has used a ¼-inch (6mm) plate-glass palette atop replaceable sheets of white paper. This provides a clean, reflective mixing surface. Initially the Holbein Duo Aqua Oil exhibited a noticeable drag when any water was added to the mixing process—perhaps due to the glass palette. He found this was not true when using the manufacturer's linseed oil or painting medium as the sole solvent and extender. Indeed, the colors quickly mixed to the buttery consistency he

favors with oils and left virtually no film or trace when wiped off the palette with a paper towel.

Huntoon's efforts in developing *Reflections* consisted first of constructing his palette in the usual way—creating a value scale. Each color is tinted with white and mixed with a painting medium so that it can be applied as a value-scaled underpainting. The entire range of colors is accurately painted in with small- to medium-sized brushes beginning with the lightest areas, usually the sky or water surface reflections. He maintains all of the light/dark contrasts of clouds, foliage, rocks, etc., as he moves gradually toward the deepest shades of foreground shadows.

Necessary hues were mixed using Cobalt Blue, Light Yellow, Medium Green and Scarlet. The Scarlet is an integral element in toning down the vividness of the blue and the green, and

Glazing With Water-Soluble Oils

The ability of the water-soluble oils to provide an appearance of translucency with layers of glazed color was a welcome revelation. The paint compared favorably in every way to traditional oil colors.

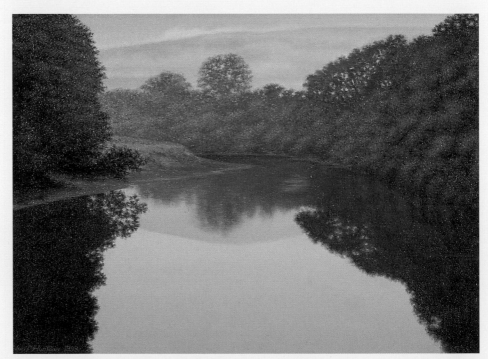

Reflections · Robert Huntoon · Water-soluble oil on canvas · 10" × 14" (25cm × 36cm)

makes possible a complete range of natural-looking vegetation.

Once mixed, the water-soluble oils retained their elasticity and spreadability for over forty-eight hours at room temperature, and for over four days when refrigerated each night thereafter. When some stiffening became apparent on the third day, a few drops of additional linseed oil returned the paints to their full workable consistency. Some skinning occurred on the palette-side surface on the fourth day, but the majority of the paint remained quite workable.

The painted canvas dried to the touch by the third day, but matching color, experimentally applied from the palette, continued to blend very well. For this stage, Huntoon allowed the underpainting to dry for three days before beginning the next layer. He made a new palette similar to the first, but extended the range of values. The entire surface of the painting was reworked. After two days of building this second layer, the paint, which was mixed solely with linseed oil, showed a tendency to crawl or pull away from the prepainted surface to which it was applied. When this occurs with traditional oils, Huntoon wipes the surface with a turpentine-dampened rag to regain tooth. With the water-soluble oils, all that was necessary was a light scrub with a water-dampened cloth, and a workable surface immediately returned.

Several key background areas required further touching up to improve their textural contrast. A third layer of detailing was added using the same second-level palette; specifically, the top layers of distant foliage had to emerge. Huntoon was surprised at how controllable the sought-after softness of these textural details was possible in this medium. His overall goal of achieving apparently seamless expanses of clear space, along with a rich medley of softly blended middle tones, was effected. Indeed, in a recent display of paintings, where *Reflections* was placed among his other oil landscapes, it proved indistinguishable in both palette and surface from the other work. Huntoon thinks the finished result is as convincing an argument as he could want as to the suitability of the medium.

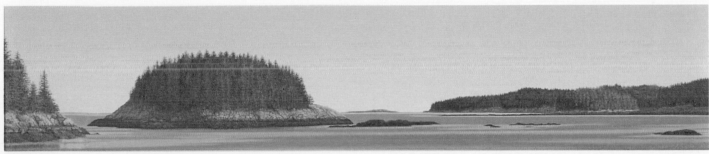

Traditional Oils Show Translucency

Large expanses of sky and water are best rendered with multiple layers of translucent paint. This layering achieves two goals: It allows the color to transmit more light and also creates a virtually seamless surface, devoid of brush marks.

Five Island Bay · Robert Huntoon · Traditional oil on canvas · 8" X 30" (20cm X 76cm)

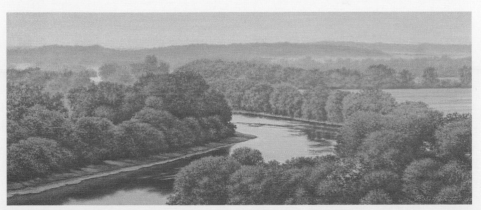

Up Around the Bend—Winooski River · Robert Huntoon · Traditional oil on canvas · 10" X 22" (25cm X 56cm)

Muted Contrast Creates Depth

Generally, softly muted backgrounds contrast effectively with more deeply shadowed foreground areas to create a sense of depth and, just as importantly, atmosphere. Diagonal compositional elements are often an essential aid in establishing this sense of distance.

Katharine Montstream

Water-soluble oils have opened up a new world for Katharine Montstream and her painting. She has been working in oils for a number of years but always with some hesitation. A fear of the long-term effects of solvents is never far from her mind. She has been painting with watercolors most of her life and enjoys the spontaneity of painting wet-into-wet. With quick brushstrokes, she can watch the painting take a direction that may not have been intended. For instance, while a watercolor painting is wet, she tips the block of paper and the paint will melt together in a way that wouldn't happen had she left the block level (see SHELBURNE POINT IN GRAYS at right). What has impressed her about water-soluble oils is the fluidity of the paint, the vivid colors that can be applied thinly or thickly and the freedom from turpentine. She loves the effect that turpentine has on traditional oils, so learning that she could use water to get the same look was very exciting. When using water-soluble oils, one of her favorite techniques is to rub back the painting with a rag to get a transparent look that mimics watercolors. The reduction process of taking away paint is new for her since she is usually adding paint throughout the watercolor process.

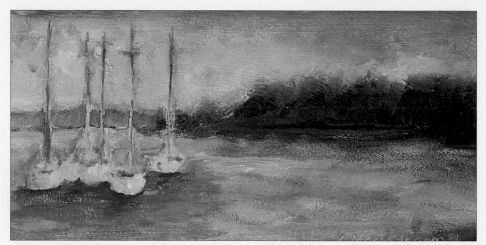

Painting From Memory
One cold morning Montstream and her sister were riding bikes on a bike path by Lake Champlain. They came around the corner and there was the harbor full of boats with the lake at one of its quieter moments. The point in the background stood strong against the masts of the boats. She painted the scene in her studio from memory.

Harbor Looking North · Katharine Montstream · Water-soluble oil on paper · 5" X 12" (13cm X 30cm)

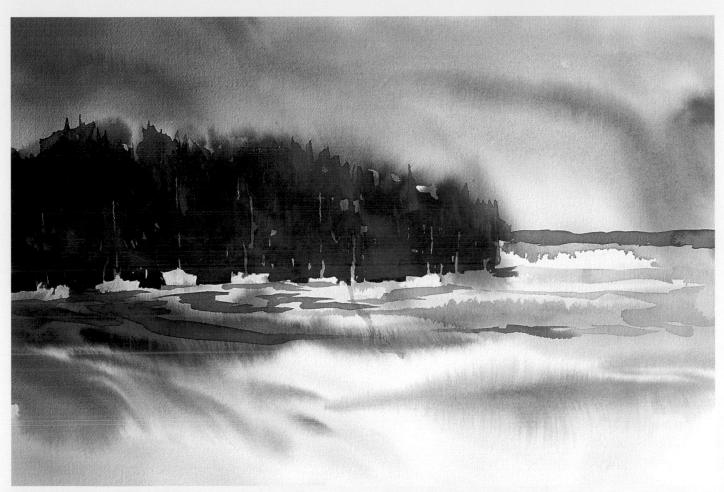

Watercolor Painted Wet-Into-Wet

This watercolor was painted on location with a huge rainstorm looming on the horizon. It finally caught up to Montstream, and you can see the slightest raindrop in the sky that hit the painting while it was still wet. Adrenaline mixed with the painting process can be very effective.

Shelburne Point in Grays · Katharine Montstream · Watercolor on paper · 18" × 24" (46cm × 61cm)

Ned Mueller

tip
The new water-soluble oils work best with the water-soluble linseed oil.

Ned Mueller was born in Milwaukee, Wisconsin, and grew up in Montana. As long as he can remember, he has had an attraction to making art, especially drawing and painting. Throughout his childhood and teenage years, he received encouragement from both his family and teachers to pursue his art. Today he works in the Seattle, Washington, area. Mueller works in traditional oils and pastels most of the time.

Mueller has a growing concern, as do many other artists, that turpentine and other chemicals used in traditional oil painting are becoming too much of a danger to work with. This is what stimulated Mueller to try the water-soluble oil paints. He considers the cleanup and safety factors of water-soluble oil paints to be a major benefit. He has noticed that while the water-soluble oils work very similarly to traditional oils, they dry somewhat quicker even when painting wet-into-wet. He said the pigments

seemed to be just as strong as oil paints with an equivalent tinting power.

Mueller works both en plein air and in the studio. His goal is to achieve a feel of light and color harmony in his work. However, before he begins he must find an exciting subject matter that he is truly interested in, or he feels that he will be left with a dull painting.

Mueller's palette consists of Alizarin Crimson, Titanium White, Cadmium Orange, Cadmium Red Light, Cadmium Yellow Light, Cobalt Blue, Ivory Black, Transparent Red Oxide, Viridian Green and Ultramarine Blue. He uses mineral spirits when he works with traditional oils but when he uses water-soluble oil, Mueller uses water-soluble linseed oil medium. He begins his painting process by doing a small value study before painting on a larger canvas. He blocks in his values in the bigger areas and works from large to small shapes while trying to keep a sense of rhythm and motion in

Traditional Glazing Captures Sunset
Mueller has created a beautiful sense of light. The reflections in the water are powerful, but at the same time he keeps the light soft and misty. His tight sense of composition with use of glazing has captured the moment as the sun sets in Portugal.

Sunset—Lagos, Portugal · Ned Mueller · Traditional oil on canvas · 10" X 13" (25cm X 33cm) · Private collection

Mueller's work in water-soluble oil is comparable to his traditional oil painting. His interest in capturing a sense of light is dominant in both paintings. His use of color with water-soluble oil is slightly stronger than that of his gently mixed traditional oil colors. However, Mueller was very happy with the way the pigments worked for him.

Morning Glow · Ned Mueller. · Water-soluble oil on canvas · 12" X 16" (30cm X 41cm) · Private collection

MORNING GLOW Detail

Here we get a closer look at Mueller's painting style. His strokes are active but not abrupt. His style is very painterly. His use of color is slightly more intense than his work in traditional oils. This may be because of his interest in capturing the differences in daylight as well as the reflection of the light on the water.

Sketch for MORNING GLOW

Before beginning a painting, Mueller starts with a value study. Next he paints a sketch on the surface of his canvas to block out his composition and set things up for a successful painting. The sketch is done with an oil wash and brush.

Kevin Macpherson

Kevin Macpherson and his wife, Wanda, are bitten with wanderlust. They spend nearly half of each year traveling and painting throughout the world. Flying with solvents for oil painting is prohibited, so traveling with water-soluble oil paints allows them to be ready to paint as soon as they reach their destination. The water-soluble oils offer an alternative to the search for and transportation of toxic solvents.

The Macphersons also spend many painting trips in their small camper. Camping in a confined space with wet paintings and noxious fumes is neither enjoyable nor healthy, so the water-soluble oils work well in this situation. And cleanup is as easy as using a baby wipe to clean hands.

Macpherson has noticed some drawbacks with the water-soluble oils. He is careful not to use too much water with his paints. He does not want too much water to become trapped between layers. In one painting he applied a thin wash but noticed some chipping on the surface once it dried. Also, the surface when dried has a different feel than oils.

Some colors, such as Cadmium Yellow Light, are not as intense as traditional oils, and Ultramarine Blue does not have the same clean brilliance of traditional oils.

Capture Local Beauty
For this painting Macpherson added Thalo Green to his normal palette of Cadmium Yellow Light, Alizarin Crimson, Ultramarine Blue and Titanium White. The Thalo Green helps capture the beautiful water and colorful shutters of Bermuda in this picturesque view.

Bermuda Rooftops · Kevin Macpherson · Water-soluble oil · 6" X 8" (15cm X 20cm)

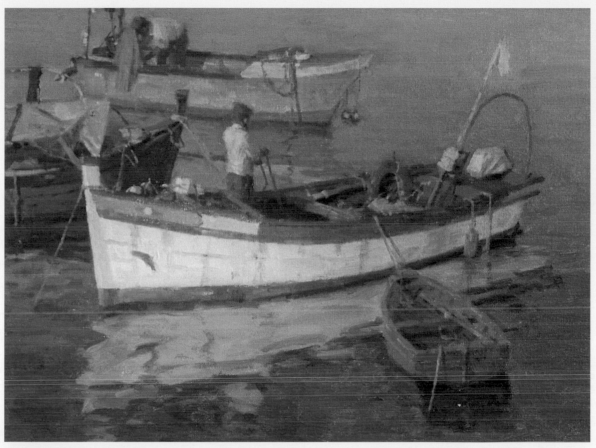

Water-Soluble Oils Reflect the Glow of Morning Sunlight

Mueller's work in water-soluble oil is comparable to his traditional oil painting. His interest in capturing a sense of light is dominant in both paintings. His use of color with water-soluble oil is slightly stronger than that of his gently mixed traditional oil colors. However, Mueller was very happy with the way the pigments worked for him.

Morning Glow · Ned Mueller · Water-soluble oil on canvas · 12" X 16" (30cm X 41cm) · Private collection

MORNING GLOW Detail

Here we get a closer look at Mueller's painting style. His strokes are active but not abrupt. His style is very painterly. His use of color is slightly more intense than his work in traditional oils. This may be because of his interest in capturing the differences in daylight as well as the reflection of the light on the water.

Sketch for MORNING GLOW

Before beginning a painting, Mueller starts with a value study. Next he paints a sketch on the surface of his canvas to block out his composition and set things up for a successful painting. The sketch is done with an oil wash and brush.

Kevin Macpherson

Kevin Macpherson and his wife, Wanda, are bitten with wanderlust. They spend nearly half of each year traveling and painting throughout the world. Flying with solvents for oil painting is prohibited, so traveling with water-soluble oil paints allows them to be ready to paint as soon as they reach their destination. The water-soluble oils offer an alternative to the search for and transportation of toxic solvents.

The Macphersons also spend many painting trips in their small camper. Camping in a confined space with wet paintings and noxious fumes is neither enjoyable nor healthy, so the water-soluble oils work well in this situation. And cleanup is as easy as using a baby wipe to clean hands.

Macpherson has noticed some drawbacks with the water-soluble oils. He is careful not to use too much water with his paints. He does not want too much water to become trapped between layers. In one painting he applied a thin wash but noticed some chipping on the surface once it dried. Also, the surface when dried has a different feel than oils.

Some colors, such as Cadmium Yellow Light, are not as intense as traditional oils, and Ultramarine Blue does not have the same clean brilliance of traditional oils.

Capture Local Beauty

For this painting Macpherson added Thalo Green to his normal palette of Cadmium Yellow Light, Alizarin Crimson, Ultramarine Blue and Titanium White. The Thalo Green helps capture the beautiful water and colorful shutters of Bermuda in this picturesque view.

Bermuda Rooftops · Kevin Macpherson · Water-soluble oil · 6" X 8" (15cm X 20cm)

Tropical Light Zihuatanejo, Mexico · Kevin Macpherson · Water-soluble oil · 8" × 10" (20cm × 25cm)

Keep Your Palette Simple

The light quickly faded as Macpherson captured the silhouette of the banana tree in shadow. His palette consisted of Cadmium Yellow Light, Alizarin Crimson, Ultramarine Blue and Titanium White. This keeps his painting process simple.

Painting on Clay Board

A small boat took the Macphersons out to a Mexican island for snorkeling and painting. He painted with water-soluble oils on clay board. The clay surface was more absorbent than canvas, which created dry-brush techniques in some areas of the painting. The masseurs posed while taking a break.

Baja Massage · Kevin Macpherson · Water-soluble oil on clay board · 6" × 8" (15cm × 20cm)

Concentrate While Painting

Macpherson stood at the ocean's edge while curious onlookers watched his every stroke. He was not distracted by their many comments in Spanish.

Mexican Boats on the Beach · Kevin Macpherson · Water-soluble oil · 8" × 10" (20cm × 25cm)

Perfect for Travel
On the beach painting, what could be better? The colorful sails attracted Macpherson's attention. A container of water in his backpack made it convenient to paint without the difficulty of finding solvents.

Boats for Sail · Kevin Macpherson · Water-soluble oil · 8" × 10" (20cm × 25cm)

Create Small Plein Air Paintings
The warm afternoon light changes quickly; painting small offers the chance to capture this elusive beauty.

Bermuda Glow · Kevin Macpherson · Water-soluble oil · 8" × 10" (20cm × 25cm)

ARTISTS' THOUGHTS ON WATER-SOLUBLE OILS **89**

Wanda Macpherson

Wanda Macpherson has been painting with water-soluble oils for a few years. They are great for traveling because they don't need any smelly solvents. She doesn't use any medium with the water-soluble oils. Her palette, which she uses all the time, consists of Titanium White, Cadmium Yellow Light, Ultramarine Blue, Alizarin Crimson and a small dab of Thalo Green.

Macpherson has been toning her canvas with Yellow Ochre mixed with Raw Sienna to create a light wash, which she uses to wipe off her gessoed watercolor paper. She likes some of the wash to come through her paintings. She likes the feel and dryness she obtains from using the paper. She is able to layer the different colors onto the dry surface. There is one drawback to the water-soluble oils: Sometimes when they get too cold or dry, she feels the paint stiffens up and becomes difficult to work with.

Capture the Morning Light
Wanda Macpherson and her husband, Kevin, spent three weeks one spring painting in Napa Valley. The grape leaves were just coming out with the spring green on the old vines. This painting was captured in the morning light. She always paints small with her Pochade box on a tripod.

Napa Valley · Wanda Macpherson · Water-soluble oil on gessoed paper · 6" × 8" (15cm × 20cm)

Boats for Sail · Kevin Macpherson · Water-soluble oil · 8" X 10" (20cm X 25cm)

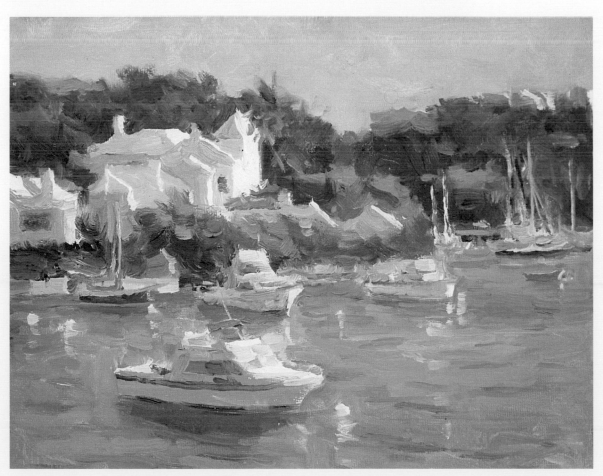

Create Small Plein Air Paintings
The warm afternoon light changes quickly; painting small offers the chance to capture this elusive beauty.

Bermuda Glow · Kevin Macpherson · Water-soluble oil · 8" X 10" (20cm X 25cm)

Wanda Macpherson

Wanda Macpherson has been painting with water-soluble oils for a few years. They are great for traveling because they don't need any smelly solvents. She doesn't use any medium with the water-soluble oils. Her palette, which she uses all the time, consists of Titanium White, Cadmium Yellow Light, Ultramarine Blue, Alizarin Crimson and a small dab of Thalo Green.

Macpherson has been toning her canvas with Yellow Ochre mixed with Raw Sienna to create a light wash, which she uses to wipe off her gessoed watercolor paper. She likes some of the wash to come through her paintings. She likes the feel and dryness she obtains from using the paper. She is able to layer the different colors onto the dry surface. There is one drawback to the water-soluble oils: Sometimes when they get too cold or dry, she feels the paint stiffens up and becomes difficult to work with.

Capture the Morning Light
Wanda Macpherson and her husband, Kevin, spent three weeks one spring painting in Napa Valley. The grape leaves were just coming out with the spring green on the old vines. This painting was captured in the morning light. She always paints small with her Pochade box on a tripod.

Napa Valley · Wanda Macpherson · Water-soluble oil on gessoed paper · 6" X 8" (15cm X 20cm)

Paint Quickly to Capture the Light
Macpherson came upon this view late one afternoon while driving around. She had to paint fast to capture the late light. She tried to capture the different depths, atmosphere and pattern she saw.

View From Pedroncelli Winery • Wanda Macpherson • Water-soluble oil on gessoed paper • 6" X 8" (15cm X 20cm)

Use Artistic License to Compliment Perfection
This view was a perfect setup for a painting. It was painted from the deck of the restaurant at the Chateau Souverain Winery. A tractor kept going up and down the row of the vineyards. It was a fun experience to paint in the Napa Valley and capture the different rows of the vineyards. Macpherson took a little artistic license and added a little greenery on the vines instead of just having sticks in the painting.

Chateau Souverain Vista • Wanda Macpherson • Water-soluble oil on gessoed paper • 8" X 10" (20cm X 25cm)

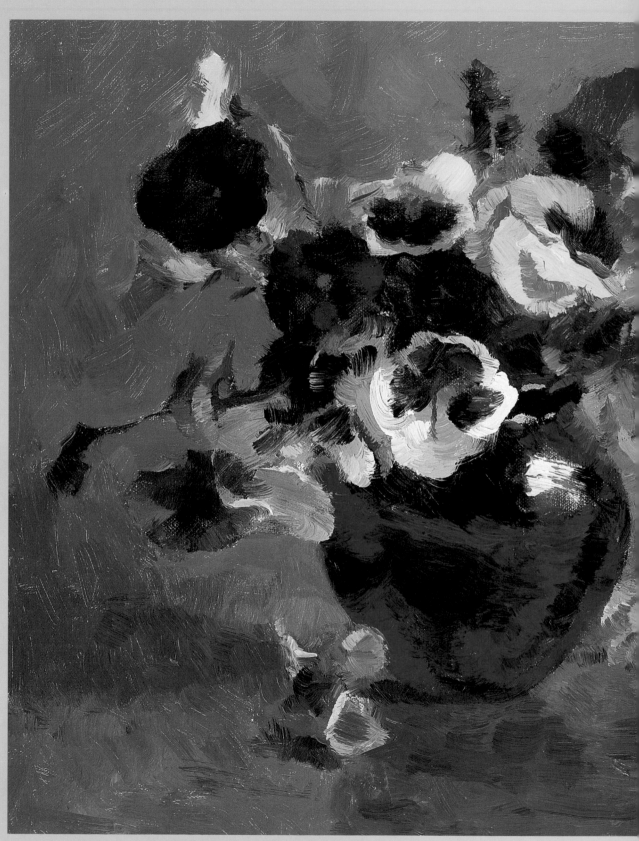

Pansies · Kevin Macpherson · Water-soluble oil · 12" X 14" (30cm X 36cm)

chapter four
STEP-BY-STEP DEMONSTRATIONS

Each of the artists in this chapter has broken his or her painting technique down into specific steps. By looking at these steps, you will be able to see how each artist approaches the construction of a painting and specifically how they each craft a work using water-soluble oils. You will see artists attaining different levels of detail and learn what aspects of painting are most important to each individual.

materials list

HOLBEIN DUO AQUA OILS
Marigold • Olive Green • Orange • Sap Green

VAN GOGH H₂OILS
Indian Yellow

WINSOR & NEWTON ARTISAN WATER MIXABLE OIL COLORS
Alizarin Crimson • Burnt Sienna • Cadmium Red Light • Cadmium Red Medium • Cadmium Yellow Medium • Cerulean Blue • French Ultramarine • Lemon Yellow • Permanent Alizarin Crimson • Phthalo Green (Blue Shade) • Titanium White • Ultramarine Blue • Zinc White

BRUSHES
½-inch (12mm) flat • 1-inch (25mm) flat • No. 12 Holbein K hog bristle flat • Nos. 8 and 12 Holbein Resable series flat • c220 Nylon flats • Nos. 8 and 12 watercolor rounds • No. 12 Winsor & Newton Artisan filbert

OTHER
India ink • Winsor & Newton Artisan Fast Drying Medium

I chose this image for a number of reasons. First, I thought it would be interesting to make a painting that did not have a clear focal point. Second, I thought this subject matter would present some new exciting challenges. The complexity of the tree trunks and the multitude of very dark areas would indeed be a challenge.

This pond is connected to a small lake about a mile from my studio. I made a watercolor and pastel sketch. I also took a couple of photographs so that I would have more than one reference for my final painting. Because a large painting of this nature is created in many layers that need to dry, it is not practical to complete it on location.

Since the darks would play a starring role in this painting I felt it was necessary to create an accurate value study. I decided to paint on a 2" (5cm) deep, gallery-style Profile Prestretched Canvas by Apollon measuring 36" × 48" (91cm × 122cm). Most prestretched canvases are not quite as bright as an artist needs them to be. Since my value study was so important, I felt that a very bright surface was crucial. I applied two coats of high-quality acrylic gesso to the canvas before starting my drawing.

Sketch on Location
I painted the basic layout of this sketch in watercolor on location. I then refined the colors in my studio using soft pastel.

Sketch for Pond with Fallen Leaves • Sean Dye • Watercolor and pastel • 12" × 18" (30cm × 46cm)

Use a palette with wells so that you can mix several concentrations of India ink. The lightest value looks like dirty water white, while the darkest value is straight India ink. Use the ½-inch (12mm) and 1-inch (25mm) flat and nos. 8 and 12 round watercolor brushes to draw—or paint—your sketch using the various shades of India ink. The many coats of high-quality acrylic gesso on the canvas create a very absorbent and bright surface.

DETAIL

Use several densities of India ink from straight ink to very pale washes. Because the canvas has many coats of gesso, the washes are easily absorbed into the surface with little dripping. Sketch in some basic shapes for the aquatic plants. You can achieve a variety of strokes using both flat and round brushes.

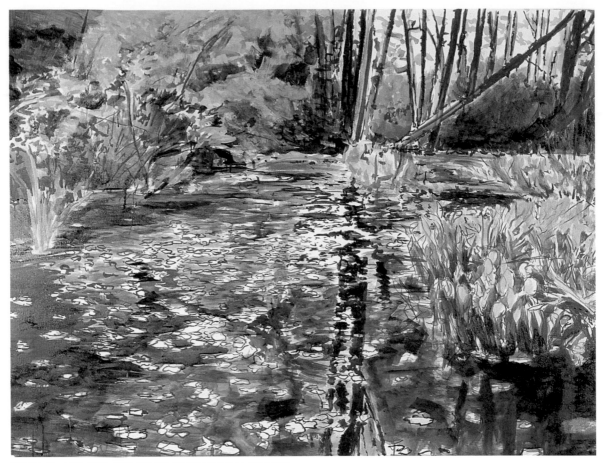

STEP 2 ADDING COLOR TO THE VALUE STUDY

Begin adding color using violet and blue-violet for the shadows. Use a mixture of Alizarin Crimson
and Ultramarine Blue for the violet-colored dark areas. For less intense color, add a bit of Burnt
Sienna to the mixture. The dark water on the left side of the painting is Phthalo Green (Blue Shade)
plus Burnt Sienna. Block in yellow-greens into the areas that will be primarily green using a mixture
of Lemon Yellow, Cadmium Yellow Medium, Zinc White and a pinch of Cadmium Red Light. All col-
ors are Artisan Water Mixable Oil Colors. Add Artisan Fast Drying Medium to all layers. Use a no.
12 Holbein K hog bristle flat brush.

DETAIL

Change the direction of your stroke depending
on what you are trying to describe with the
paint. Here, even at this early stage, you should
keep all of your strokes in the water horizontal.
This helps to keep the plane of the water flat
and perpendicular to the picture plane. A com-
bination of warm, cool, bright and more neutral
violets is used.

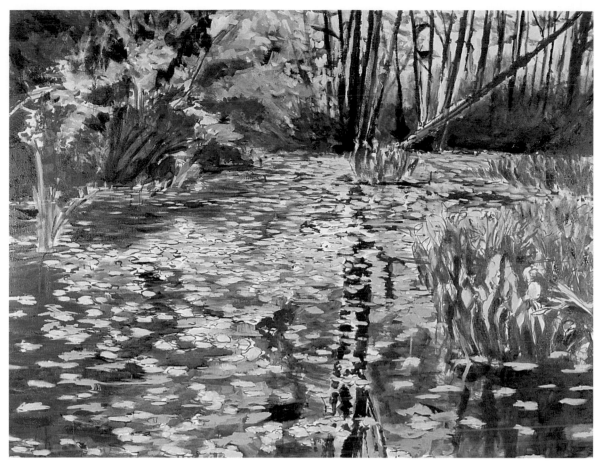

STEP 3 COVERING THE VIOLET UNDERPAINTING

Introduce blue greens into the darker green areas. Paint a layer of pale yellow as a base color for the fallen leaves. Use a mixture of Titanium White, Alizarin Crimson and a pinch of Van Gogh H$_2$Oil Indian Yellow for the sky between the trees.

Use Titanium White, Alizarin Crimson and Ultramarine Blue to define the sky reflection in the water.

The first layer on the fallen leaves is a mixture of Zinc White with Cadmium Yellow Medium and a speck of Cadmium Red Medium.

For the foliage that was previously violet, create a thin glaze of blue-green made with Phthalo Green (Blue Shade), French Ultramarine and Cerulean Blue.

Use Holbein Resable series 220 Nylon nos. 8 and 12 flats. These brushes are stiff enough to handle oil paint but have plenty of flexibility to react to every stroke.

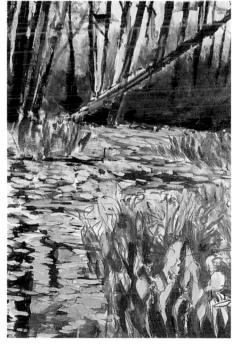

DETAIL

A thin glaze of the blue-green is applied to the distant trees that were originally violet. Notice how both colors are visible here. A light blue-violet begins showing the reflection of the sky in the water.

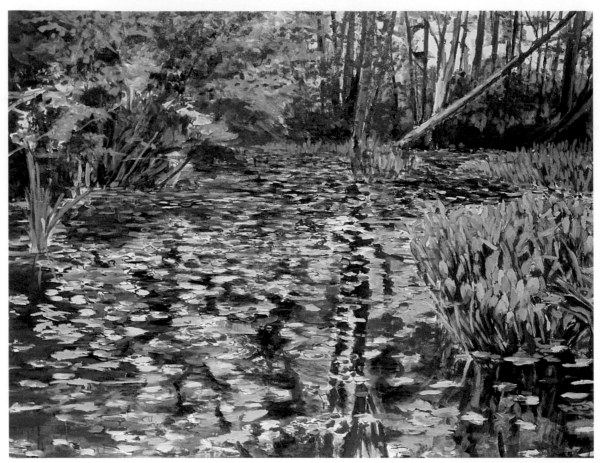

STEP 4 PULLING IT TOGETHER AND ADDING WARMTH

Bring the painting to life with natural green, red and orange colors. Paint the negative space in the water by adding more colors. This will suggest reflections of trees.

Expand the selections of yellows and greens. The introduction of red in the leaves sets the season and offers a strong warm/cool contrast. Rework much of the water to make the shadow areas darker and richer and the reflections lighter and more vibrant.

Add detail to the foreground plants and the trees. Warm the background trees with the Duo Aqua Oil Olive Green and Sap Green plus the Artisan Cadmium Yellow Medium. Use Artisan Phthalo Green (Blue Shade), Cadmium Yellow Medium, Cadmium Red Medium and Zinc White for the light foliage. Paint the orange on the leaves with a combination of Permanent Alizarin Crimson, Cadmium Yellow Medium, Zinc White and Duo Aqua Oil Marigold. Use Permanent Alizarin Crimson, Cadmium Red Medium and Zinc White for the reds in the trees and the leaves floating on the water.

Use Artisan paints unless indicated otherwise. Use your nos. 8 and 12 flats and an Artisan no. 12 filbert, which has stiffer bristles than the Resable brushes.

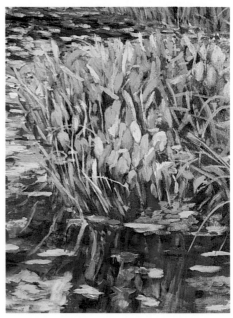

DETAIL

Notice how the light yellow-greens and some pale blue-greens have been incorporated into the plants and the many different directions and shapes in the brushstrokes.

The size of the brushstrokes changes to make the leaves in the background feel smaller than the leaves in the foreground.

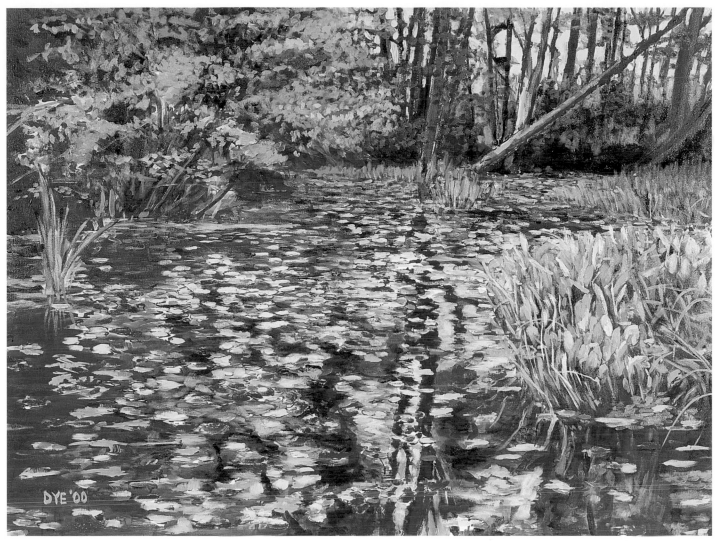

STEP 5 FINAL

Place lighter reflections from the sky in the water and a greater variety of greens in the foliage. Be sure the application of color in the fallen leaves is random. Mix it up with variations of color, being careful to make the new distribution of color feel random. Make the sky and reflections of sky lighter in some areas. Finish by adding detail in the foreground vegetation and the foliage on the trees.

Pond with Fallen Leaves · Sean Dye · Water-soluble oil on canvas · 36" × 48" (91cm × 122cm) · Collection of Steve Barrett

The Cape Cod location for this painting was photographed at low tide, revealing lots of sand and dune foliage in a horizontal format. It occurred to Huntoon that another photograph he'd taken of a particularly striking vertical cloud formation might make an admirable compositional counterpart to these dunes. He superimposed one image onto the other, using a same-size pencil tracing on vellum. The resulting contour sketch suggested a perfect match.

When working from photos, Huntoon doesn't attempt to match the exact colors suggested by the print dyes. Keep the overall value of the colors about 30 to 40 percent lighter in tone than the photograph. This allows for a greater degree of brightness in the painting and a broader range of light and dark values. It also allows more freedom in determining the palette while maximizing the usefulness of the photo reference.

Huntoon used Holbein Duo Aqua Oils. His entire palette of tinted hues is prepared using Holbein's water-soluble linseed oil as a mixing medium. This improves the mixability and flow of the paint. It also imparts a reflective surface that can readily support layers of color.

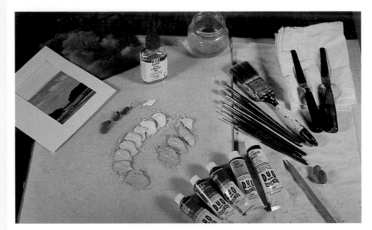

Preparing to Paint
This ¼-inch (6mm) plate-glass palette has served Huntoon for over twenty-five years. Here, the range of color for sky and clouds is prepared for the background.

STEP 1 SKETCH

Create a contour sketch traced from reference photos. Enlarge the drawing onto the canvas using a simple pencil line to define all essential shapes in the composition.

STEP 2 THE SKY

Follow the sketch and block in the sky from bottom to top, blending the values from light to dark blue.

With large areas of uninterrupted space, such as the sky, you should mix up to twelve individual values of blue, beginning with the lightest and preceding through the darkest, before applying them to the canvas. The lighter sky consists of Titanium White, Cobalt Blue and a smidgen each of Permanent Green and Cadmium Red. The darker sky contains additional blue and a touch of red. Apply the colors in horizontal strata, bottom to top (light to dark), and blend them together. Use the 1½-inch (38mm) house painting brush to drybrush the blended seams, creating the smoothest possible transition.

tip

When mixing in a pigment with such staining power as red, practice moderation. With light tints, a little goes a very long way. With darker areas, add a little at a time, mixing the resultant color thoroughly with a palette knife before adding more. Soon you'll become proficient at establishing your own formula for favorite tints and tones. Begin with patience; it will be your best guide.

STEP 3 WORK LIGHT TO DARK

Working from light areas to dark, add the dimensional values of the clouds. Carefully blend the edges where contrast defines the shapes.

Dynamic light and shadow are the most powerful ingredients in this composition. In the clouds, there are both subtle and stark contrasts in equal measure. Working in the shapes of the lightest areas first, then the next lightest, and so on, reveals a gradual sense of dimension. The highlight areas are predominantly white, with a smidgen of yellow and red. The midtones begin with white, contain slightly more yellow and red, and introduce a touch of blue. The darkest areas possess the same ingredients as the midtones, but contain larger amounts of red and blue.

As you apply each area of color, carefully blend its edge with its neighboring color. A no. 1 round brush is ideal for small areas as is a no. 6 for larger, amorphous shapes. The edge where the clouds meet the sky must always be kept soft and slightly blurred. This same order of applying light areas first, dark areas next and then blending the edges is a procedure you'll follow throughout the painting.

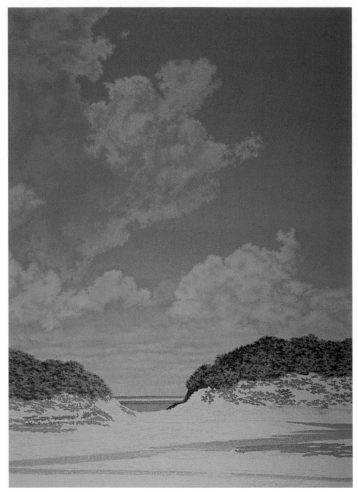

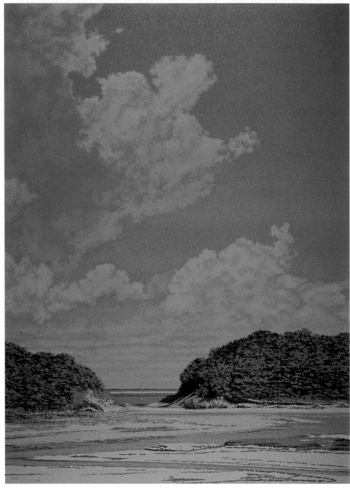

STEP 4 THE FOLIAGE

Enter the lighter (highlight) foliage areas first, then the darker (shadow) areas, methodically blurring the edges to ensure a soft texture.

Begin the dune foliage of light greens with Titanium White, a small amount of Permanent Green and equal dashes of Cadmium Yellow Pale and Cadmium Red. The dark greens are predominantly Permanent Green and Cobalt Blue, with a fair measure of red added to tone them down. Lay in the sandy foreground area with another combination of tints and tones. Make the peachy, highly lit areas mostly white, with trace amounts of yellow and red. The midtones contain a trifle more yellow and red, plus a bit of Burnt Sienna. Add a touch of Cobalt Blue to these same warm midtone colors to dull them significantly and turn them into cool browns. Use Burnt Sienna mixed with additional red and even more blue to create the darkest shadows. The remaining color in the foreground provides the utmost color contrast. Paint the **S** curve of the low-tide water using the same blues as the sky.

STEP 5 THE FOREGROUND

Working from light to dark again, shape the sandy foreground with highlights and midtones.

Keep the wet edges of light and dark areas from blurring. This is a constant challenge. Carefully seam these puzzle shapes with a clean brush. This is demanding but rewarding, as this preserves the identity of the individual landscape elements. A careful underpainting—which must dry for about a week—is the perfect foundation for developing a more fully realized range of textures and values.

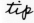

Since the painting will be constructed in several layers, Huntoon must prepare enough paint for each layer plus a sample of each individual tint for matching colors in successive layers. The inverted lids of plastic deli containers make suitable storage containers for samples. When sealed around the edge with masking tape, they may be kept in the freezer for up to two weeks, warmed to room temperature and reused.

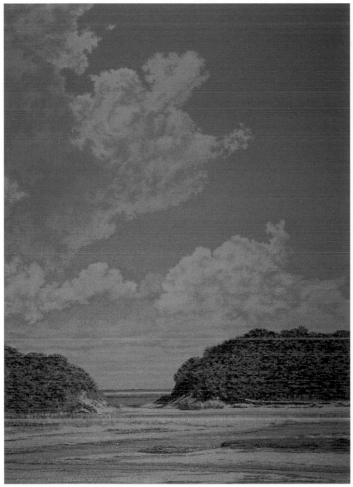

STEP 6 THE COMPLETED UNDERPAINTING

Complete the foreground highlight and midtones, remembering to work from light to dark. The completed underpainting—an effective color study—has little of the tonal variety and textural richness that develops with further applications of color.

Prepare a new palette, referring to samples from the first layer. Supply the same broad range of tints and tones as in the underpainting. It is a good habit to mix this second stage with a bit more water-soluble linseed oil. This will promote greater translucency in the paint, leading to a greater sense of depth. This new layer of color—by virtue of its translucency—permits light to travel into the surface of the pigment before being reflected back to the viewer. Rather than obscuring the underpainting, the new layers create additional richness of color.

STEP 7 THE SECOND LAYER OF SKY

Prepare another more darkly contrasting array of blues for the second layer. Paint the sky again working from light (bottom) to dark (top). Allow the new sky to dry for several days. Mix a slightly darker range of blues using the same formula as before but with a greater amount of Cobalt Blue near the top. Apply a third layer, giving the sky a deeper accent than before. Repaint the clouds, this time with slightly brighter highlights (less yellow and red in the white) and darker shadows (more red and blue). Wet-blend all the second-layer colors around their edges, just as before, with particular care where they meet the sky. FEATHERING—twisting a no. 0 round brush from the cloud's edge outward into the sky (and constantly wiping it clean of any blue paint it picks up)—lends the clouds a wispier contour. This will increase the contrast between sky and clouds. Use the 1½-inch (38mm) house painting brush to vigorously blend the third layer of blue. This translucent layer of color conveys a greater sense of depth.

STEP 8 SECOND-LAYER FORE-GROUND AND HIGHLIGHTS

Create warmer, more red-tinted highlights and midtones to contrast with the cool blues of the water. Paint hints of detail throughout the foreground and deep dune shadows using cooler midtone browns. Use a no. 00 round brush.

Paint the strong shadows along the edges of the sand dunes with Permanent Green darkened with Cadmium Red, Cobalt Blue and Burnt Sienna. Add a second layer of highlights and shadows. Though laborious, this process will promote a softer, richer textural surface.

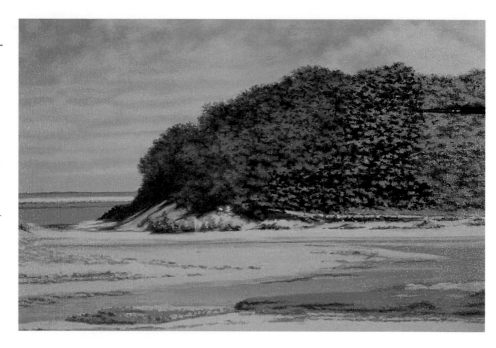

STEP 9 FINISHING TOUCHES

Final touches include these unifying highlights that lend a sunnier aspect to the foliage canopy.

Mixing a lighter tint from the lightest green already on the palette, add the finishing touches of highlights on the foliage while the second-layer greens are still drying. A bit more white, a bit more yellow and a hint of red are all it takes to suggest a sun-baked canopy.

When you reach a point when you sense you may be able to walk into the picture, actually breathe in this space you've created, feel the warmth of the sun and cast a shadow, you've arrived at the end of your journey.

creating darks

For many years, Huntoon has eliminated black from his palette, finding it uninteresting as well as unnecessary. When an especially deep shadow is needed in foliage areas, for instance, additional amounts of red and blue will darken the greens to any desired tone.

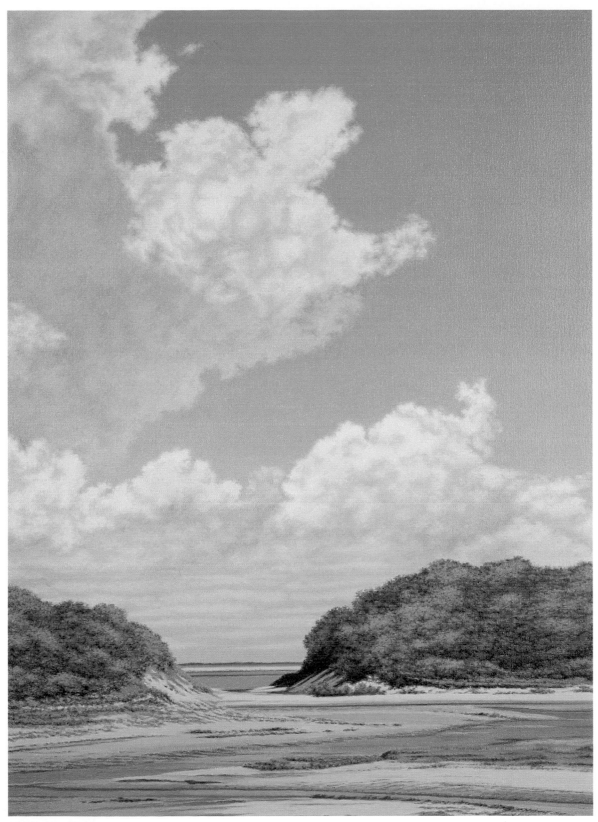

STEP 10 FINAL

The finished canvas achieves a greater degree of atmosphere than is possible with a single reflective layer of color.

Cloudsong · Robert Huntoon · Water-soluble oil on stretched canvas · 30" X 22" (76cm X 56cm)

materials list

WINSOR & NEWTON ARTISAN WATER MIXABLE OIL COLORS
Cadmium Red Medium • Cadmium Yellow Medium • Cerulean Blue • Cobalt Blue • Lemon Yellow • Orange • Permanent Alizarin Crimson • Titanium White • Ultramarine Blue Yellow Ochre

HOLBEIN DUO AQUA OILS
Blue Violet • Deep Red • Deep Yellow • Light Magenta • Payne's Grey

VAN GOGH H₂OILS
Indian Yellow • Permanent Green Medium

GOLDEN ACRYLICS
Cadmium Orange • Cadmium Yellow Dark • Cerulean Blue • Cobalt Green • Jenkins Green Medium Magenta • Payne's Gray • Pyrolle Red • Quinacridone Magenta

UTRECHT ACRYLICS
Cadmium Yellow Light • Cadmium Yellow Medium • Cobalt Blue • Naphthol Red Deep Permanent Hooker's Green • Raw Umber • Titanium White • Ultramarine Blue • Yellow Ochre

MEDIUMS
Liquitex Mat Varnish (Satin Finish) mixed with water • Holbein Duo Aqua Oil Water-Soluble Linseed Oil • Winsor & Newton Artisan Oil Fast Drying Medium

BRUSHES
¼-inch (6mm) flat (soft bristle) • ½-inch (12mm) flat (soft bristle) • Small round sables

This painting is part of a long series of works from the gardens at Basin Harbor Club in Vergennes, Vermont. When working in the studio, Jeanette Chupack works from slides taken on location, supplemented by drawings and color sketches, which give her firsthand knowledge of the scene. The basic composition is usually derived from a slide of the overall scene. A series of detail slides fill in the information needed to complete the painting. The painting process is simplified into a series of steps to facilitate painting quickly in oil and acrylic.

Working quickly is important to Chupack for maintaining the spontaneity and unity of the piece, as well as keeping up with demand for her paintings.

STEP 1 REFERENCE PHOTOGRAPH

Select your composition based on a reference photograph. Remember you can alter your reference photograph if needed. You will notice changes in the light on the chair and the elimination of some details, such as the chair behind the Adirondack chairs, as well as some simplification of the background.

STEP 2 CREATE A LINE DRAWING

Begin with an acrylic line drawing using Raw Umber on a canvas prepared with four coats of gesso. Draw carefully, indicating major compositional elements as well as some placement of details. Focus on the details of the chairs, the area behind them and the placement of the various flower groupings. Chupack often begins this stage by projecting the slide onto the canvas, drawing the elements from the slide that she can use and then correcting for perspective, composition and details. Establish some values, but leave as much white canvas as possible to allow for the brilliant color to show through.

STEP 3 ACRYLIC WASH

Proceed with thin washes of acrylic color to establish the major color areas. With some of the white canvas showing through, this is where you should visualize the finished piece. At every stage after this, try to keep the immediacy and freshness of this step.

STEP 4 FINAL ACRYLIC WASHES AND PAINTING

Proceed to fill in and eliminate all of the white canvas with thin washes of acrylic paint. Work as you would with watercolor, being careful to keep the color and value that you want in the finished painting. Finish the areas in the background behind the major flower groupings, including the chairs, with the acrylic medium. Apply the paint more heavily in these areas because you won't be working over them with the water-soluble oils. This helps to avoid any adhesion problems, as the oils will be applied over the thin watercolor-like acrylic paint, which still retains the absorbency of the gesso.

STEP 5 PAINTING THE WATER-SOLUBLE OILS

The water-soluble oils give a richness of surface depth and color to the foliage to the left of the chairs. Lay in the heavier areas of color and the detail of the flowers. Next spend some time working on the foliage surrounding the flowers, working on everything except the grass in front on the lower third of the canvas. Use Winsor & Newton Artisan Fast Drying Medium for water-soluble oils diluted with a small amount of water. This allows for quick drying for overpainting and for brilliant glazes over the acrylic washes. For this entire step, use somewhat soft-bristled flats in ¼-inch (6mm) and ½-inch (12mm) sizes and small round sables for the finest detail.

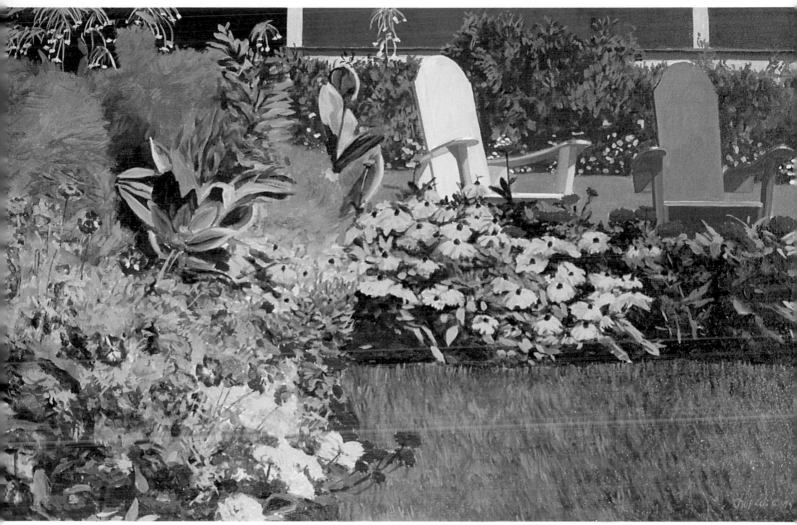

STEP 6 FINAL

At this point the large grassy area in the foreground needs detail and a slightly darker value. Use a harder-bristle brush to provide texture. Work with three types of greens, mixed ahead, in three different values and apply them in conjunction with one another. Use just enough medium to allow some of the underlying color to come through. Using short strokes and the side of the brush, create the texture of mown grass. Never use harsh greens from the tube; always mix them with either Cadmium Reds, Cadmium Oranges, Yellow Ochre, Dioxazine Purple or a combination of these plus yellow and white. Chupack prefers Hooker's Green, Cobalt Green and Permanent Green. After the grass is laid in, go back into the foliage of flowers on the left, lighten it and add more detail. Wait about twenty-four hours before attempting to overpaint with crisp detail and color. Here is where the faster drying time of the water-soluble oil is a big bonus. Of course Chupack finds that cleanup is the greatest advantage to this medium.

Garden Chairs II · Jeanette Chupack · Water-soluble oil and acrylic on canvas · 18" X 27" (46cm X 69cm)

materials list

HOLBEIN DUO AQUA OILS

Alizarin Crimson • Burnt Sienna • Burnt Umber • Deep Red • Indigo • Lemon • Light Green • Light Yellow • Marine Blue • Orange • Raw Sienna • Sap Green • Titanium White • Ultramarine Blue • Violet • Viridian • Yellow • Yellow Ochre

MAX GRUMBACHER ARTISTS' OIL COLORS

Alizarin Crimson • Cadmium-Barium Red Light • Cadmium-Barium Yellow Medium • Cerulean Blue • French Ultramarine Blue • Sap Green • Titanium White • Viridian • Yellow Ochre

OTHER

Nos. 4 and 6 flat Holbein Resable • Nos. 4 and 6 bright Holbein Resable • Nos. 2 and 4 Maestro KW

Caroline Jasper begins each of her oil paintings on a bright red ground. While the process of working on a toned ground is not unprecedented, the use of red as a ground color is rather unconventional.

Her primary interest is light; she always locates and paints highlights first. All subsequent color decisions during the course of painting revolve around the white areas. Therefore, painting on a white ground did not suit her needs. She did not want to begin a painting with what she strove to avoid: dull color.

By not painting to cover every bit of the surface, the colors are less likely to become muddied from mixing with one another on the canvas. Allowing the ground color to show through in small amounts provides a unifying effect to the finished painting. Most ground colors she tried tended to blend in with newly painted colors. Red's interaction with other colors is dramatic. Red has a medium value, contrasts with the white highlights and becomes a middle tone once the darkest shadows are added. Jasper permits red to permeate the painting surface, separating colors and shapes as needed for visual impact. Among the various reds, she has tried Carmine, Naphthol and Cadmium Reds. Her favorite is Cadmium Red Light.

Jasper seals stretched canvas with an opaque coating of gesso. She uses Cadmium Red Light for the red ground. This application is so saturated with pigment that brilliant color can be achieved using only a thin coating.

Next, Jasper establishes strong contrast in the initial stages of the painting, first recording highlights then darker shadows. A tube of black paint is never found in her paint box. Instead, she suggests creating black with mixtures of the darkest colors available. She does little color mixing or blending on canvas. Instead, she builds an image with premixed shapes of individual color, each relating to her interpretation of value and intensity. She pushes contrast in the foreground while dulling or fading background colors. Final brushstrokes brighten important white areas with added opacity.

Caroline Jasper's easel setup for EXPECTATIONS.

tip

Light is the most important element when aiming to create a sense of place and time in this landscape painting. All color decisions will relate to the presence of light, so white is the first paint applied to the canvas. Search photo references of the subject for indications of sunlight. Surfaces that directly face the light source reflect the strongest highlights, often washing out details and reducing local color to near white.

STEP 1 FIND THE LIGHT

Cover the painting surface with a medium red or darker ground color, against which white paint will show up. Before starting to paint, sketch the image in simple contour lines.

Apply pure Titanium White onto the canvas to represent all highlights. Spread the paint thickly or thinly, changing opacity to suggest varying degrees of lightness. Areas where the red ground is less covered should appear as lesser highlights. All unpainted areas, tree trunks, branch silhouettes, shrubs and remaining land areas will read as being in shadow.

STEP 2 DEFINE HIGHLIGHTS

Backlighting creates a dramatic play of light and shadow, causing the shadows to fall toward the foreground. Remember that land color always relates to sky color, and that the sky is always lighter nearer to the horizon. Blend small amounts of Marine Blue (similar to Cerulean Blue) into the still wet white shapes between the upper branches to suggest overhead sky. The sun's glare on the local colors of the fall leaves shows the greatest color intensity. Apply the brightest yellows available, Yellow and Lemon, to the strongly lit ground and leaf sections among the even stronger whites. Paint these to represent the sun's brightest effects.

tip

The key to creating a sense of depth in landscape painting is atmospheric perspective, in which the appearance of deep space is the result of layers of haze between foreground and distant background. Foreground areas appear brighter in color with more value contrast and more details. Using already employed highlight colors, record lighter details within the darker foreground tree trunks and their cast shadows.

tip

Value contrast is vital to visually confirm the closeness of foreground areas. The brightest white highlights in the foreground must be accompanied by the darkest colors in the painting to make the foreground dominant. This backlighting generates bold foreground shadows cast from the nearest trees, which are also in shadow.

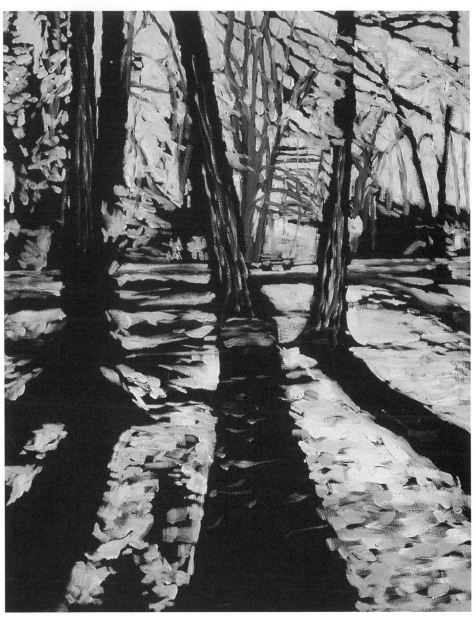

STEP 3 CREATE DEPTH AND ILLUSION

Mix Ultramarine Blue with a touch of Orange, a touch of Alizarin Crimson and a little white. Paint simple background tree shapes, either into the unpainted spaces reserved for them or directly over the pale sky. Cooler colors are effective in portraying depth because they recede visually. Apply similarly mixed faded dark colors to represent shadow areas in the midground section between the closer trees and the wooded background. In the most distant background areas, paint covering most of the red ground, negating red's tendency to heighten the intensity of lighter and contrasting colors. Apply this treatment either while the sky is still wet or after drying.

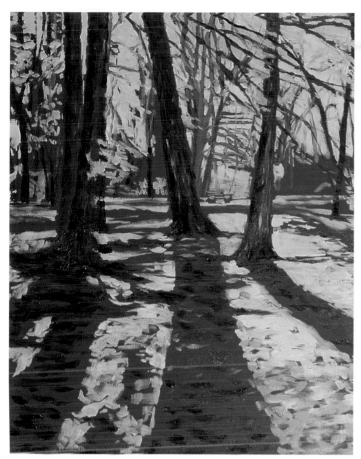

STEP 4 ESTABLISH CONTRAST

Subscribing to the Impressionistic belief that pure black does not exist, that color is always present, mix the darkest colors available from your palette. Various combinations of Ultramarine Blue, Alizarin Crimson and Viridian—perhaps neutralized with a touch of Orange—will serve as rich darks. Use your "black" mixtures to record the darkest shapes within the foreground shadows. It is best to apply these darkest shadow sections after previously painted areas have hardened, so that light and dark areas will not mix and dilute each other.

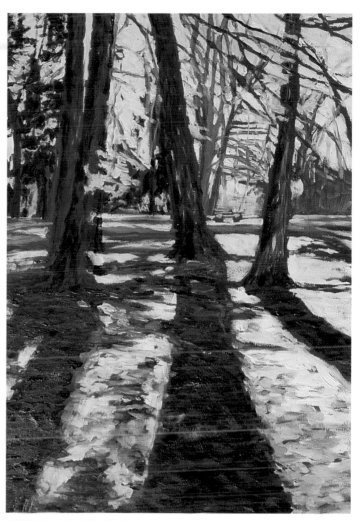

STEP 5 DEVELOP FOREGROUND COLOR

Using bold strokes, brush on shapes of color, alternating different green mixtures to represent foreground lighting and color changes in both shadow and highlight areas. Apply bits of duller colors like Yellow Ochre and Raw Sienna to add interest to midground areas.

The red ground plays a significant role in foreground areas. Intentionally paint out most of the red in the background, allowing the red to remain uncovered between brushstrokes in the foreground. The brighter foreground greens complement the red and stimulate its intensity, emphasizing closeness and implying movement.

color tip

To increase foreground interest, observe the range of colors present in your reference photos. Determine which colors on the palette may best represent these color differences. The use of Viridian for cooler colors and Sap Green for warmer colors are mainstays for landscape painting. Mixtures of Marine Blue and Yellow in various percentages produce an extremely vibrant range of greens. Add Ultramarine Blue to darken and Deep Red or Orange to "brown down" green for earthiness.

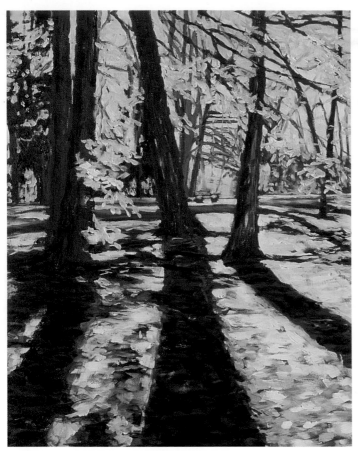

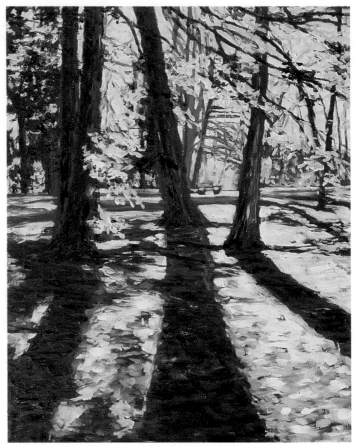

STEP 6 STRENGTHEN SHADOWS

Increase the percentages of Ultramarine Blue and Alizarin Crimson in the green mixtures for the shadow details. The darkest shadows are found in the foreground; therefore, more visible details must be developed. Brush these darker shapes in and between previously recorded lighter and brighter shadow sections. Incorporated judiciously, Indigo—one of the darkest colors—can increase shadow depth and effectiveness.

STEP 7 DEVELOP DETAIL AND DEPTH

Allow the painting to dry, and apply details that overlap the foreground and background. Paint leafy branches that interrupt the sky, wooded background and portions of foreground tree trunks. Mix Lemon with Sap Green for brightly lit foreground leaf sections. Use a heavily loaded brush to achieve opacity in applying these leaf groupings.

Allow the tree branches to dry. Create a glaze using water-soluble linseed oil—or just water—on the palette and adding a small amount of white. If the background is too bright, include a touch of any complementary background color. Apply this glaze over the most distant background areas to suggest a haze. Once dried, apply additional layers of glaze over select portions to suggest distant land masses. Reducing color differences and contrast visually pushes back the background. The more it differs from the colorful contrasts of the detailed foreground, the more the background complements the foreground.

Review the basic value contrast upon which the painting was founded. Revisit the highlights to identify those areas that show the strongest reflection of the sun's glare. Brush on additional white in the highlights to increase opacity and brighten the white. Lastly, identify the darkest shadow areas. Increase their effectiveness as shadows by adding opaque strokes of a mixture of darker colors.

Expectations · Caroline Jasper · Water-soluble oil on canvas · 20" X 16" (51cm X 41cm) · Collection of the artist

materials list

WINSOR & NEWTON ARTISAN WATER MIXABLE OIL COLOR

Alizarin Crimson • Cadmium Red Medium • Cadmium Yellow Medium • Cerulean Blue • Cobalt Blue • French Ultramarine • Ivory Black • Lemon Yellow • Titanium White

BRUSHES

No. 4 filbert • No. 4 round • Nos. 1, 2 and 3 pointed round • No. 6 short bright

OTHER

Winsor & Newton Artisan Water Mixable Fast Drying Medium • Water-mixable linseed oil

Reed Prescott III paints both from photo references and on location. He has the most fun when he finds a nice spot, takes a fresh canvas and starts painting. The changing light conditions force him to paint efficiently. The experience of location work is transferred to the studio, giving the paintings he creates from photographs a dimension that can only come as a result of the location painting experiences.

On location Prescott sets up at a site and starts by finding a center of interest. He thinks about textures, brushstrokes and compositional elements that can be used to lead the viewer into the painting and to the chosen center of interest. He paints on a toned canvas using a mixture of a light to medium gray with any two complementary colors plus white thinned down to an inklike consistency.

He sketches in the basic forms being careful to avoid detail. The goal is to create a map for the next step, the blocking in of colors. It is important to realize that nothing is written in stone at this point. He draws, corrects the sketch and may even wipe a canvas clean until he is comfortable with the composition and perspective.

Once the painting is mapped out, Prescott starts blocking in color. He covers the entire canvas and then adjusts the colors. Once the entire canvas is covered Prescott sets it aside until the next day.

On the second day Prescott identifies the center of interest and then begins to add depth to the painting. He works from the background to foreground creating depth by making sure the darkest darks are in the foreground and lightest colors are in the background. Next he focuses on detail and texture, getting it just right until the painting is finished.

PHOTOGRAPHY BY TAD MERRICK

Photos for Compilation

EARLY MORNING AT WILDERNEATH was created from a series of photographs taken on location. The three photos Prescott uses were taken at three different locations and are combined to re-create a memory from the previous summer. Prescott alters the colors and light captured in the photographs to create the image he wants.

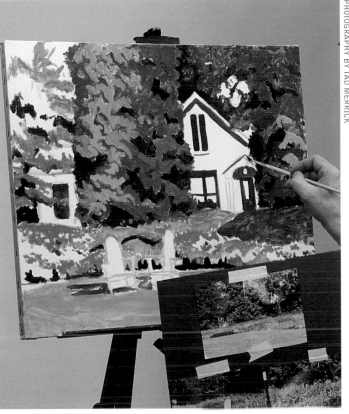

STEP 1 MAKE A PRIMARY SKETCH

With paint thinned to the consistency of drawing ink, draw the basic shapes to create a map for the painting. You may draw, correct and draw again until the composition and perspective are to your liking. Next, define the drawing as if adding roads to a map. Do not begin shading at this stage. This is a quick definition of shapes used to prepare for the next step, the blocking in of color.

STEP 2 BLOCK IN COLOR

Work on larger areas first and limit your palette to a few colors from each area. Quickly block in the painting. Use a warm shade of green for the grass and a cooler shade of green for the shadows created by the chairs. Two cooler shades and two warmer shades are found in the cedar hedge that frames the cottage. These variations are enough to give form and a sense of light.

the palette

Lay out your palette like a spectrum. The colors should appear from left to right: Titanium White, Cadmium Lemon Yellow, an orange, Cadmium Red Medium, a green, Cerulean Blue, Cobalt Blue, Ultramarine Blue, a violet and a black. With yellow, orange and red as the warm colors and green, blue and violet as the cool colors, you can mix the full range of colors needed to create realism in your work. Mix all of your greens, browns and grays from primary colors while using secondary colors to tone down or lessen the intensity of the mixed colors.

The base color of an object will be mixed with all of the colors on the palette to create ten different shades of that base color. For example, the leaves on a tree will be mixed using a medium-value base color of green. Working across the palette, add some yellow with the green, some yellow and orange with the green, some orange, some orange and red, then some red to create five different light to medium warm shades of the green base color. Mix medium to dark shades with the cool colors to create the shadow colors. Keep warm shades separate from cool shades to give an object depth and shape.

It is important to be aware of the reflective color on the shadow side. This will be the color from a nearby object. Some colors absorb more light while others reflect it.

STEP 3 PAINT QUICKLY

Progress quickly, moving to areas of finer detail.
Still use a limited palette to paint the flower bed
with purple, orange and pink flowers surrounded
with green foliage, all painted with one or two
shades of each color. Lay in the cottage with a
warm and cool choice of color.

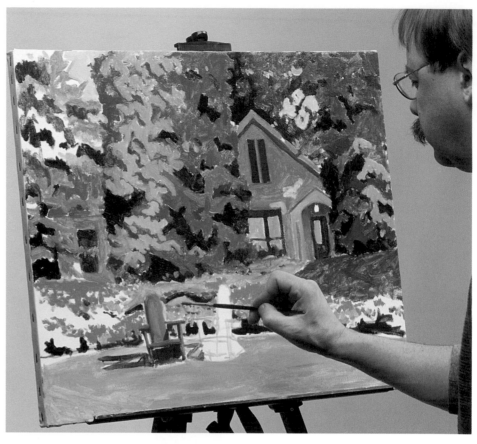

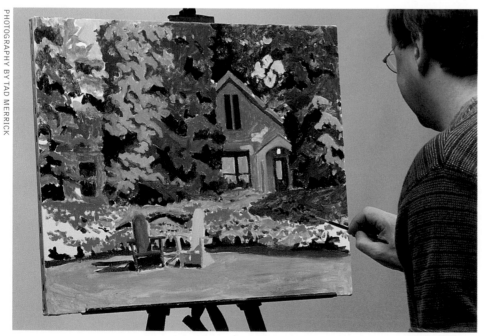

STEP 4 ADD COLOR

Identify the center of interest and refine the
detail by adding a few more colors to each area.
Add shadow to the lawn on the right from a tree
not visible in the painting. This creates the effect
of early, morning long shadows. Take your time
and start to use smaller brushes as you add
detail. This stage might take two or three sit-
tings. Create depth in the lawn by adding darker
shades to the foreground. Once the whole paint-
ing is at an equal level of detail, step back and
evaluate the painting before going onto the final
detailing stage.

STEP 5 CENTER OF INTEREST

Focus on the center of interest—the chairs. Tighten up the detail from the point of interest, working out to the edges of the canvas. The entire canvas should now be covered to some level.

STEP 6
ADD DETAILS

Continue to detail the flower beds and lawn.

STEP 7 FINE-TUNE YOUR PAINTING

Go back in for some final detail work and fine-tuning to complete the painting.

DETAIL
The details in the chairs, tree and flower garden have been refined.

STEP 8 FINAL

The painting is complete. The sense of light cast along the background shrubs really draws the viewer into the painting.

Early Morning at Wilderneath · Reed Prescott III · Water-soluble oil on canvas · 18" × 24" (46cm × 61cm)

when is a painting finished?

"I have been asked many times, 'How do you know when a painting is finished?' In reality, a painting is never finished. You can always make changes or improvements, but you reach a point when those changes have little impact on the piece. Once the changes become insignificant, and I have learned all that I can from that piece, I sign the painting and it is finished. Any wishes or potential improvements are stored in my memory for future paintings. I acknowledge what I have learned and move on to the next lesson."

materials list

ACRYLICS
Cadmium Red Light • Cadmium Yellow Medium • Yellow Ochre

HOLBEIN DUO AQUA OILS
Indigo • Lilac

VAN GOGH H₂OILS
Alizarin Crimson • Azo Yellow Deep • Azo Yellow Light • Burnt Sienna • Indian Yellow • Naphthol Red Light • Naphthol Red Violet • Permanent Blue Violet • Permanent Green Light • Permanent Green Medium • Prussian Blue • Quinacridone Rose • Titanium White • Ultramarine Blue • Zinc White

WATERCOLORS
Carmine • Payne's Gray • Permanent Yellow Deep • Ultramarine Blue

OTHER
1-inch (25mm) and 1½-inch (38mm) flat natural/nylon blend watercolor brushes • No.12 round natural/nylon blend watercolor brush • No. 12 nylon Holbein Resable brush • Grumbacher QuickDry • Holbein Gesso

Since this is one of my favorite locations, I was inspired to paint it again (see page 8). This time I am trying to capture the scene later in the season. The fall colors are just beginning to appear. I moved to the left and I have added more weight to the right side of the painting. This shift in weight occurs both at the top and bottom of the painting. This one is on a 36" × 49" (91cm × 124cm) stretched canvas.

Working on a Toned Ground

I like to have color to react to when I'm painting. I decided to give the canvas an overall tone before I started to make color decisions. I poured about ½ cup (100ml) of Holbein's M (medium smooth) gesso into a can and then added a good-sized glob of both Yellow Ochre and Cadmium Yellow Medium acrylic paint. To make this mixture slightly more orange, I added a pinch of Cadmium Red Light. It is important to stir this mixture thoroughly to achieve one continuous tone on the canvas. Since the acrylic paint is highly pigmented and added in such small quantities, it does not decrease the absorbency of the gesso.

For this painting I used a no.12 nylon Resable brush by Holbein. This brush has long flexible bristles that come to a sharp flat tip. This makes the brush ideal for wide, smooth strokes or thinner detailed strokes when turned on its side.

For all of the layers in this painting I added various quantities of Grumbacher QuickDry. For the early stage of the painting, I added quite a bit of water to the paint and QuickDry to make washes just slightly thicker than watercolor.

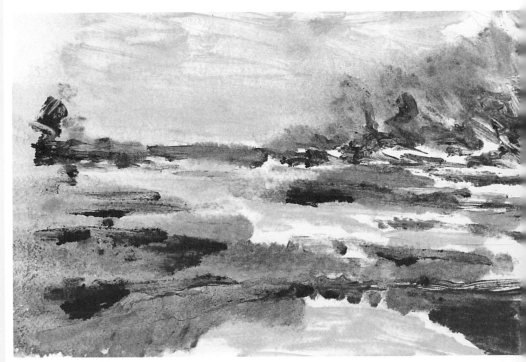

Begin With Color Sketches
This loose monotype was used as a sketch to lay out the colors.

Sketch for Entrance to Hogan Pond II · Sean Dye · Monotype in water-soluble oil 9" × 12" (23cm × 30cm)

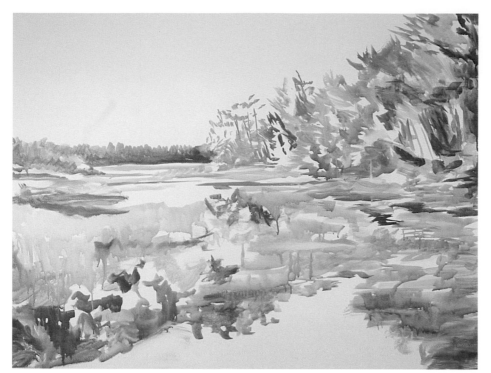

STEP 1 UNDERPAINT WITH WATER-COLOR WASHES

Watercolor is a safe medium to put underneath oil paint. The oil will penetrate the watercolor, essentially turning the watercolor layers into oil paint. It dries quickly and if you use a large brush, it is possible to lay out a large canvas in a short amount of time. The canvas already has color, so it is not necessary to cover all of the canvas.

Start with a warm yellow gesso base. Next, apply watercolor in loose washes using the 1-inch (25mm) and 1½-inch (38mm) brushes. The colors are similar to what they will become in the final version.

color combinations

It is difficult to record all of the mixtures used in fine-tuning a painting, but I will try. Colors are Van Gogh H_2Oils unless indicated otherwise. For the sky I used Ultramarine Blue, Zinc White and Holbein's Lilac. For some of the lighter greens, I used Prussian Blue, Azo Yellow Deep, Indian Yellow and Zinc White in various amounts. For some of the dry grasses, I used Titanium White, Azo Yellow Deep, Naphthol Red Light and a tiny pinch of Permanent Blue Violet.

DETAIL

The watercolor was applied in wet washes that occasionally drip. Use a paper towel to catch any long drips. The short ones add spontaneity and texture to this layer of the painting. The layers of watercolor are thin enough to allow much of the ground's warmth to come through.

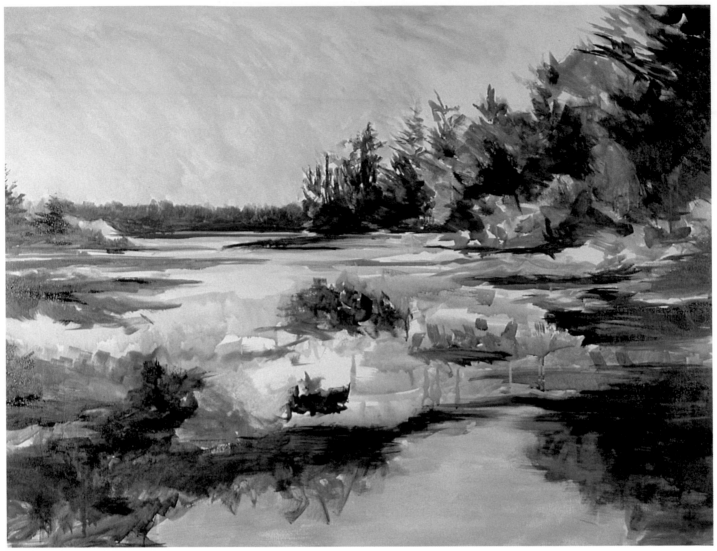

STEP 2 BLOCK IN COLOR

Paint some pale reddish colors in the sky and reflections of the sky in the water. Put blue-greens into the shadow areas and yellow-green in the highlight areas.

All color mixtures are Van Gogh H$_2$Oils unless otherwise indicated. For the sky and distant water use a mixture of Zinc White, Quinacridone Rose and Indian Yellow. This warm mixture will eventually shine through. For the foreground water use Naphthol Red Light, Azo Yellow Deep and Titanium White. For the dark and shadow areas use Permanent Blue Violet, Ultramarine Blue, Prussian Blue and Burnt Sienna. Vary these dark areas as in nature. Use Prussian Blue for the warmer areas and Ultramarine Blue or Permanent Blue Violet for the cooler areas. If the dark needs to be less intense or neutral, add more Burnt Sienna.

Notice the various densities of blue, blue-green and blue-violet.

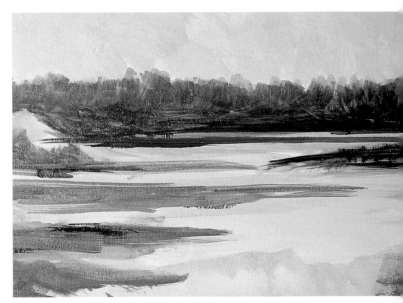

DETAIL
This photograph shows the different opacities of paint. Notice how transparent the blue-green on the distant trees is compared to the light reddish color in the water.

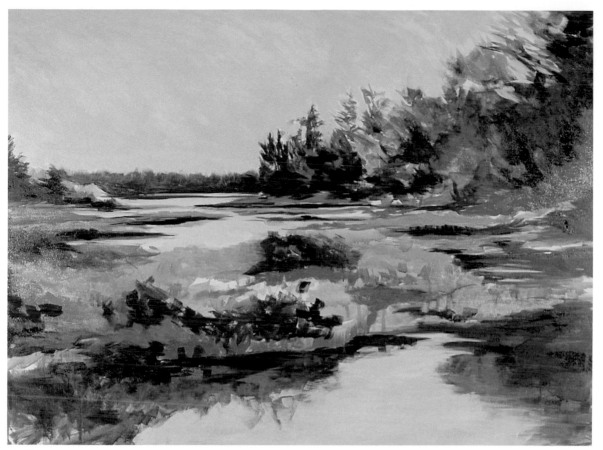

STEP 3 REFINE THE NATURAL COLOR

Add some of the more natural blues to the sky and water. The layers of paint are thin enough that previous layers show through. Create a mixture of Naphthol Red Light, Indian Yellow and Zinc White for the reddish orange foliage in the center of the painting. For the dark and shadow areas use mixtures of Prussian Blue, Alizarin Crimson and Holbein's Indigo. Start with Permanent Green Light and neutralize it with Naphthol Red Light for the dark green foliage. Make it darker and cooler by adding Ultramarine Blue. For areas receiving more light, add yellow-green created from a mixture of Permanent Green Medium, Azo Yellow Light and a pinch of Naphthol Red Violet. For the sky and its reflection in the water, use Ultramarine Blue and Alizarin Crimson tinted with Zinc White.

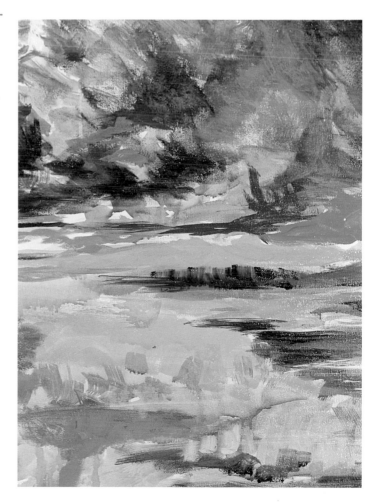

DETAIL
Some brighter greens make their way into the painting. The reddish orange color offers warm contrast to the blues and greens.

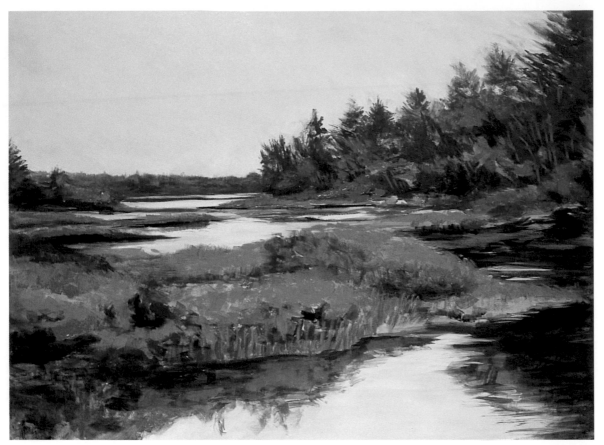

STEP 4 FINE-TUNING

The painting begins to form a believable place. Add another layer of paint to the sky to obscure the underpainting a bit more and make it feel like it is emitting more light. Develop more variety in the greens in the foreground vegetation to give a greater sense of form to this landmass. Put more detail in the trees and refine the reflections in the water. Most of the yellow gesso has been reduced to little blasts of color peeking out from behind the greens and blues. Rework some of the shadows.

DETAIL
Notice the brushstrokes in the finished painting. From a distance there appears to be some detail. However upon closer inspection the brushstrokes are actually loose, having been applied with a large flat brush.

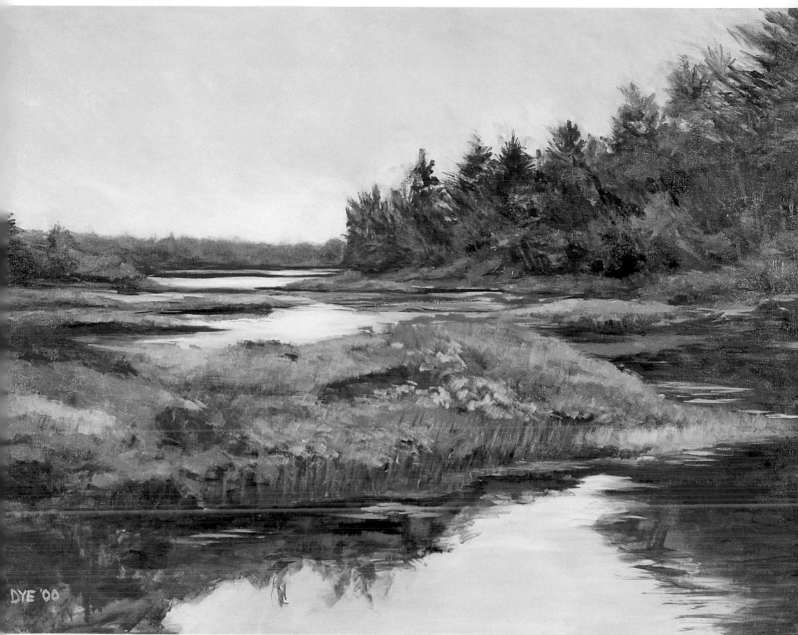

STEP 5 FINAL

Add more color and a greater range of lights and darks to the foreground vegetation. Create a greater range of values in the fingerlike landmasses in the center of the painting. Complete the reflections of plants in the water. Lighten the trees in the far background to make them recede more.

Entrance to Hagan Pond II · Sean Dye · Water soluble oil over watercolor on canvas · 36" X 48" (91cm X 122cm)

materials

HOLBEIN DUO AQUA OILS
Burnt Sienna • Orange • Titanium White •
Viridian • Yellow Ochre

**WINSOR & NEWTON ARTISAN WATER
MIXABLE OIL COLORS**
Cadmium Red Medium • Cadmium Yellow •
French Ultramarine

OTHER
Charcoal • Kneaded eraser • Palette knife •
Workable fixative

Robert Wee likes using a limited palette whenever possible to make his colors relate to each other better. To paint a seascape you do not need a wide range of colors. Wee would like to make one other point that he considers important. He says, "I have a tall stool in my studio. It is placed about eight feet back from my easel. Frequently while doing a painting, I will sit back and spend quality time just studying what I have done and what I plan to do. I find this time as important as the time I spend painting. You will be amazed at how often it will show you what is good and what is bad about your painting."

STEP 1 CHARCOAL SKETCH

Robert Wee had a firm picture in his mind of what this finished picture would look like; therefore, he did not feel the need to do a preliminary color sketch. Begin by doing a charcoal drawing directly onto a 24" × 20" (61cm × 51cm) panel. Don't just lightly sketch the major shapes. Indicate some value masses in light, halftone and shadow. Use a kneaded eraser to aid in the establishment of the light areas. Once satisfied with your composition, add fixative to the charcoal drawing.

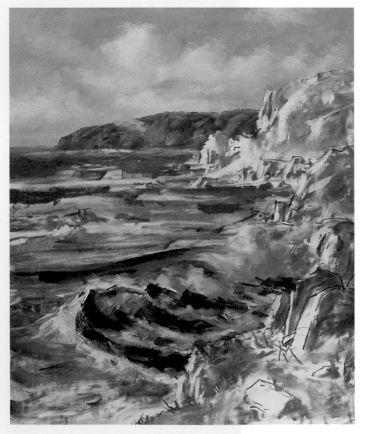

STEP 2 DEFINE THE SKY AND HEADLANDS

Begin with the sky. Lightly scrub in a thin combination of Orange and Titanium White in sort of a hit-and-miss fashion. Apply Orange—the complement of blue—to reduce the intensity of the sky. Next reduce French Ultramarine with white to create the proper value and paint over the Orange and white underpainting. Tint some Cadmium Red Medium with white and work a touch of it into the blue sky on the right-hand side to make the sky a bit violet. On the left side (where the light is coming from), put a touch of Orange into white and work a little of it into the blue of the sky. Rough in the shape of the clouds. Create the light values using Titanium White with a touch of Yellow Ochre. The gray shadows are a mixture of French Ultramarine, Cadmium Red Medium and Cadmium Yellow. The yellow is used to reduce the blue-violet to a gray. All of these colors should be reduced with white to the proper value before mixing them.

Loosely indicate the distant headland and add Burnt Sienna into the mix. Burnt Sienna, Yellow Ochre, white and a bit of gray are employed for the lights on the headland. The darks are primarily French Ultramarine, Orange and Burnt Sienna. It is important that all of these colors be lightened to the proper value with white before mixing.

STEP 3 ESTABLISH THE FOCAL POINT

Indicate the middle headland and rocks. Use the same colors as in the distant headland, except that the darks are getting darker and the lights are more intense as you come forward. It should still mainly be light, halftone and dark shapes with little attention to detail. The focal point is indicated by the crashing wave in the upper right part of the painting. Once this is established, fill in the rest of the water up to the foreground wave. This is the base over which you will place floating foam and any other necessary detail in the final stages of the painting. Also indicate a rock on the left side in the middle ground. Develop the foreground wave a little more, but keep it as just an indication of shapes with no hint of detail.

STEP 4 REFINE SHAPES AND VALUES

Complete filling in the canvas by indicating the immediate foreground on the right side. Next return your attention to the foreground wave, refining the shapes and values. Develop the floating foam. Lighten some of the water in the area of the focal point by indicating some hints of foam.

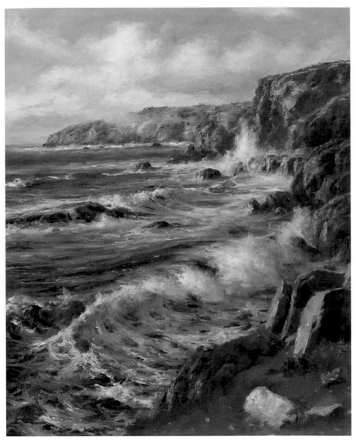

STEP 5 FINALIZE THE BACKGROUND

Go back and refine the sky and the distant headland. Scumble more fog in front of the distant headland. This is basically the same color as the shadows on the clouds. Now finalize these background areas. Work on the white water in front of the distant focal point, moving up to the foreground breaker, alternating between palette knife and brush. Define the rock in the middle on the left-hand side. Create detail in the area around the focal point by adding the water rushing over and off the rocks. Refine the foamy areas around the foreground breaker.

STEP 6 ADD DETAILS

The most obvious change at this point is the detailing of the rocks coming down the right side between the focal point and the foreground wave. Use a palette knife to indicate the light playing on the rocks. At this point refine the floating foam in front of the foreground breaker. The holes in the foam are more clearly defined than in step 5, and there are more subtle changes in the lights and halftones of the foam. Finalize the rock in the middle distance on the left, though the changes are minimal.

painting rocks

Rocks are not easy things to paint. They take so many different directions. It is very easy to overplay the lights on rocks. Just a flick here and there against a halftone is often enough. As a rule, when doing rocks the palette knife gets a good workout but always with the help of a brush.

STEP 7 FINAL

You can see into the shadows on the finished foreground headland and rocks. They are not a solid dark color. Add the grass and a few blotches of pink to indicate flowers in the right foreground. Extend the angle of the headland outward where it goes out of the picture at the bottom. Add a hint of green (a grayed Viridian lightened with Titanium White and warmed with Yellow Ochre) at the point where the water breaks over the top of the foaming foreground wave. With the addition of the background birds, the painting is finished.

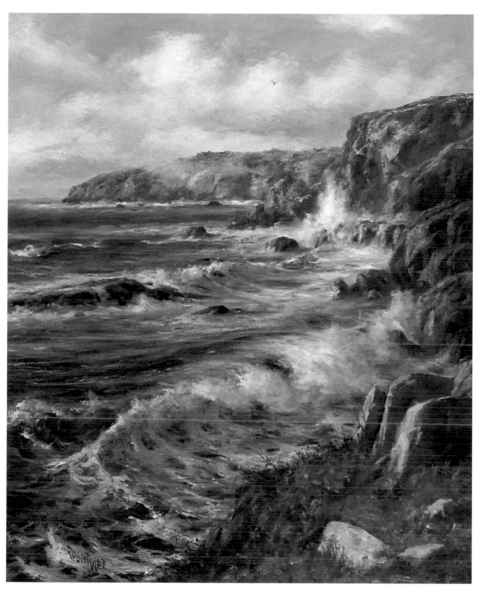

View From Above • Robert Wee • Water-soluble oil on canvas • 24" X 20" (61cm X 51cm)

painting grasses

Wee always enjoys painting grasses and foliage. He rarely attempts to show detail. He usually creates masses of color and texture with a palette knife and brush and rarely hints at tufts of grass. In this painting Wee has topped it all off with a few blotches of pink to indicate the spring flowers on the bluff.

materials list

HOLBEIN DUO AQUA OILS
Alizarin Crimson • Light Yellow • Red • Titanium White • Ultramarine Blue • Viridian

OTHER
Nos. 4–8 Holbein Series K filbert brushes • Palette knives

Kevin Macpherson's garden is rather informal, so he chooses to make his still-life arrangements reflect the natural explosion of color. A juxtaposition of colors, textures and shapes move the eye in a circular pattern throughout the canvas.

This wildflower arrangement was set up in Macpherson's studio with cool, north light as the light source on the still life and the canvas. Blue Mexican tile was placed on a board for the tabletop, along with peaches and apricots to complement the blues and repeat the colors in the bouquet.

STEP 1 USE PURE COLOR

Begin by using pure color to create an impressionistic start. Mix the paint right on the canvas, feeling through the arrangement and becoming familiar with the shapes but not locked in. No white or water is used at this stage. Do not use any medium with your paint.

 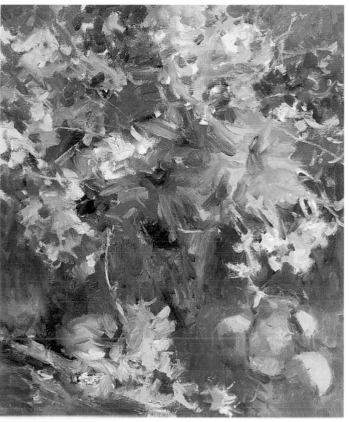

STEP 2 ADD SHADOWS AND THE BACKGROUND

You should not have touched any water yet. Change brushes as you change color families. The state of the painting is still abstract. Use white to lighten and cool off the blues.

The shadows are darker and warmer; indicate these areas loosely. The background is a mixture of all the colors on the palette. These colors produce a harmonious unmixed gray.

STEP 3 BUILD SHAPE AND FORM

The painting is still abstract and without much definition. Use the still-life setup only as a departure point, not a literal documentation. Let the shapes initially painted suggest direction, and scrape the paint off when needed to rearrange or change an area.

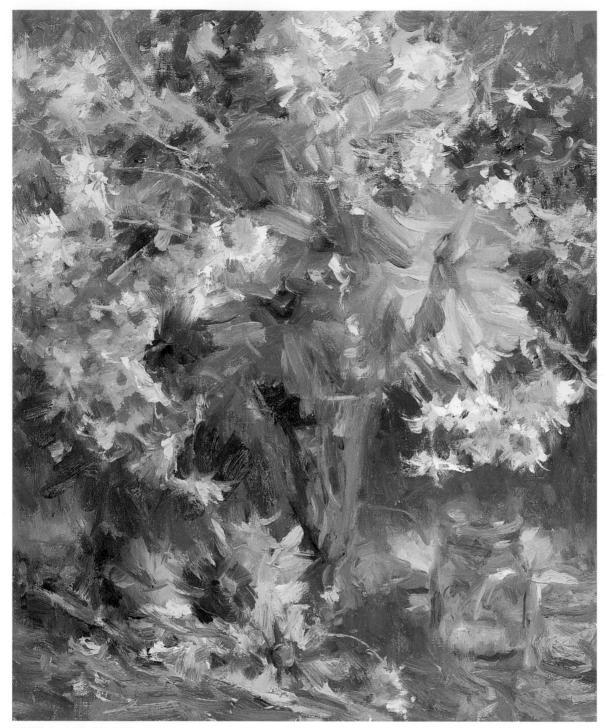

STEP 4 ADD DETAIL

The bright cool whites of the daisies define the
stems by way of negative shapes. Apply some
clean bright cool whites with a palette knife and
redefine them with the brush. The objects are
taking form at this stage.

STEP 5 FINAL (right)

The color and values of the fruit work, but the
shapes are not quite right. Transform them into
flowers to obtain a more pleasing shape. Work
throughout the canvas developing more finished
areas, continuing to move all over.

The final brings up areas of more finish,
areas with more emphasis. Scrape and change
until the desired effect and focus are achieved.

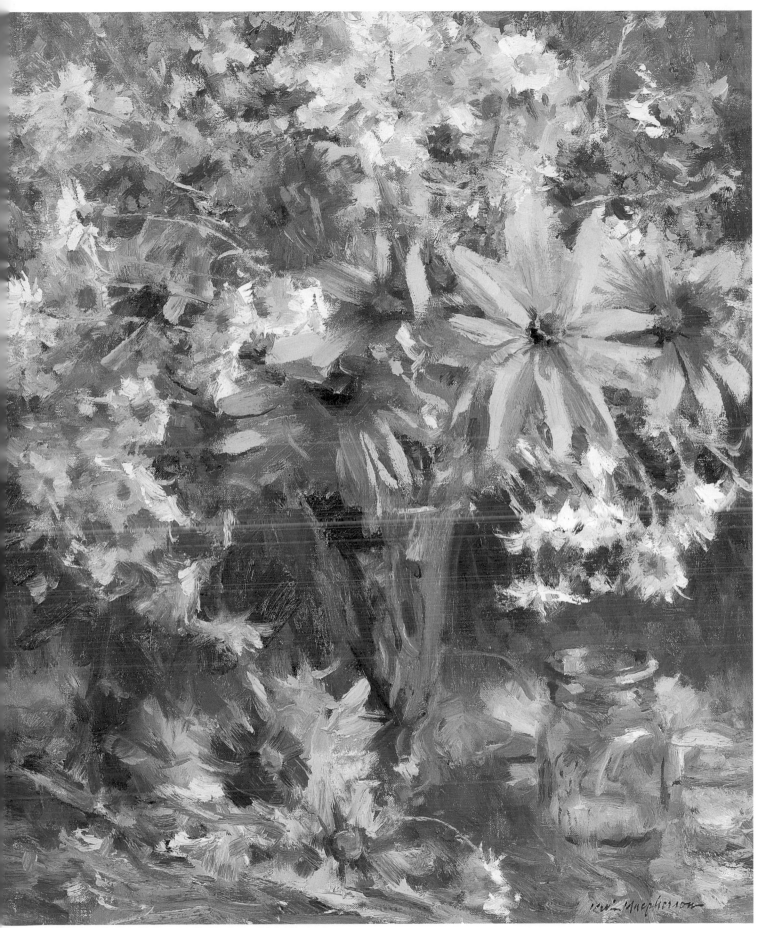

Wildflower Bouquet · Kevin Macpherson · Water-soluble oil on linen · 24" X 20" (61cm X 51cm)

about the artists

greg albert

Greg Albert graduated from the Art Academy of Cincinnati, Ohio in 1975 and received his B.F.A. from Northern Kentucky University in 1976. He continued to pursue his education at the University of Montana in Missoula, receiving an M.F.A. degree in 1978. Upon his return to Cincinnati, he worked at the Cincinnati Art Museum. In 1981, he returned to graduate school at the University of Cincinnati to study art history, receiving a master's degree in 1985. He has taught at the Art Academy of Cincinnati, Miami University and Xavier University. In 1986, Albert began his career at North Light Books where he is currently Editorial Director of Fine Art, Craft and Decorative Painting art instruction books. In 1994, his book, DRAWING: YOU CAN DO IT, an instruction book for beginners, was published by North Light Books. Albert continues to draw and paint regularly, exhibiting his work in local galleries and exhibitions. He lives in Cincinnati with his wife and daughter.

don bruner

Don Bruner was born April 21, 1953, in Winnipeg, Manitoba. Bruner's family moved a lot and lived in many small towns and isolated areas. He came to love and respect the natural environment. You can see this in his choice of subjects. He takes inspiration from the rural countryside around his studio and also from weekend trips to central and northern Ontario.

Bruner began painting in 1994 as a weekend painter. He is basically self-taught but does take his education quite seriously. Attending workshops and classes, visiting museums and reading have helped sort out his personal approach to painting.

Bruner paints many commissioned works in watercolor but when painting for himself prefers water-soluble oils.

Bruner's paintings have been published as open edition prints by Artful Creations in Toronto, Canada. His work is also featured in the video FALL COLOUR TOURS, which has been aired on commercial and public television stations in Ontario.

Bruner is married to Linda Bruner, a fellow artist, friend and very good critic. Their home and studio is shared with their four children, assorted pets and many visitors.

jeanette chupack

Jeanette Chupack is a painter who lives in Huntington, Vermont. She holds a B.F.A. from Syracuse University and an M.F.A. from Indiana University at Bloomington. She has shown her work in competitive and invitational shows since 1963, including the Butler Institute of Art, Pennsylvania Academy of Art, Mid-America Arts Alliance and Arts for the Parks. Her work can be found in collections throughout the United States including the Sheldon Memorial Art Gallery in Lincoln, Nebraska, The Chase Manhattan Collection, MBNA, and the Vermont State House. She is represented by the Clarke Galleries in Stowe, Vermont, and West Palm Beach, Florida.

robert huntoon

A 1973 graduate in fine arts from Windham College, Robert Huntoon was awarded a 1995 fellowship in painting from the Vermont Art Council and continues to work and teach in the Burlington, Vermont, area. He is exhibited at the Blue Heron Gallery in Wellfleet, Massachusetts, and at Gallery North Star in Grafton and Manchester, Vermont.

linda bruner

Linda (Keel) Bruner was born in Hampshire, England, in 1964. Her family moved to Canada in 1966 and lived and worked on many farms in the Orangeville area. The sights and scenes of this rustic community remain a deep well upon which to draw for inspiration in her art.

In 1993 Bruner enrolled in a continuing education art program, but her real education in art has been a journey of self-discovery. Through trial and error, as well as experimentation with colors, materials and techniques, she has evolved a personal style.

Bruner is a member of the Orangeville Art group, a regular participant with the High County Studio Tour and an art instructor at local private and public elementary schools.

Selected images have been published by Artful Creations in Toronto, Canada, as open edition prints. Bruner's work has been featured in the video FALL COLOUR TOURS, which has been aired on commercial and public television stations in Ontario.

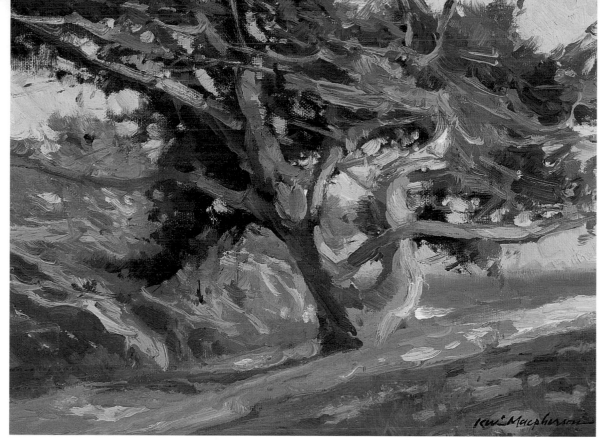

Afternoon Light · Kevin Macpherson · Water-soluble oil · 9" × 12" (23cm × 30cm)

caroline jasper

Caroline Jasper's studio is at her home in Bel Air, Maryland, where she lives with her husband and three of their four children. She holds an M.F.A. from Baltimore's Maryland Institute, College of Art, currently chairs the art department at a Maryland high school and serves on the Admissions Advisory Board at Maryland College of Art and Design.

Jasper, who exhibits in international, national and regional juried venues, has mounted seven solo exhibitions within the past four years. Among her credits are Best of Show in the Havre de Grace Arts Commission National Juried Exhibition, the Cover Award for NORTH LIGHT magazine, the Rottler Award for Excellence in the Visual Arts by the York Art Association, Pennsylvania, and inclusion in Works by Contemporary Maryland Artists, A Sense of Place at the Governor's mansion in Annapolis, Maryland. Her gallery affiliations include the Georgetown Art Guild of Washington, DC, Paper-Rock-Scissors of Baltimore, Maryland, Artists' House Gallery of Philadelphia, Pennsylvania, and The Picture Show Galleries of both Bel Air and Havre de Grace, Maryland.

kevin macpherson

Observing nature firsthand, painting en plein air, reveals the true mood of both the subject and the artist. Painting from life has given Kevin Macpherson a wealth of information; truthful color, spontaneous brushwork; numerous compositions and light conditions all available for use in larger studio works. Along with countless Best of Shows his paintings have been featured in articles in ART OF THE WEST, ART TALK and graced the covers of THE ARTIST'S MAGAZINE, SOUTHWEST ART, and AMERICAN ARTIST. Macpherson is a highly respected workshop teacher in the United States and abroad. Macpherson is the author of FILL YOUR OIL PAINTINGS WITH LIGHT AND COLOR. His book has quickly become a best-seller for North Light Books.

His past years of leadership as President of Plein Air Painters of America has brought the organization to the forefront of representational painting. He is a Master Honorary Signature Member of Oil Painters of America. Galleries in New Mexico, California and Texas represent his work. Macpherson is one of the country's leading plein air painters and is highly respected among his fellow artists and collectors. He makes his home in the mountains east of Taos, New Mexico, merging his influences from years in Arizona and his childhood memories of New Jersey. Bitten with wanderlust, Kevin and his wife, Wanda, can be seen throughout the world painting en plein air.

wanda macpherson

Wanda Macpherson began her artistic career as a sculptor but turned to painting six years ago. Today, she paints with both oils and watercolors, frequently working on location throughout the United States and Europe. She lives outside Taos, New Mexico, with her husband, Kevin Macpherson. She is a member of the American Impressionist Society and was juried into the American Impressionist Society show for the last two years.

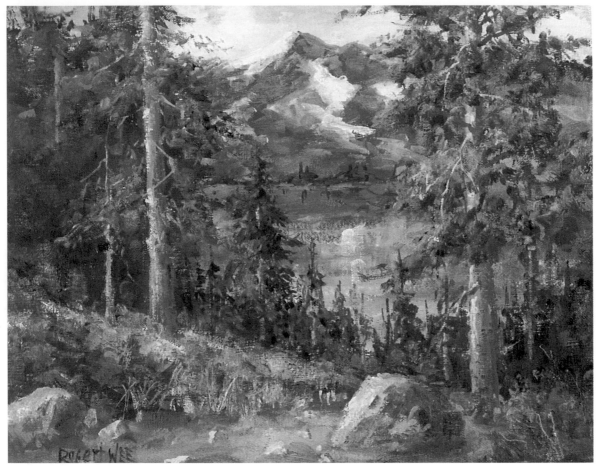

Fallen Leaf Lake · Robert Wee · Water-soluble oil · 11" × 14" (28cm × 36cm)

lynda reeves mcintyre

Lynda Reeves McIntyre is a Shelburne, Vermont, resident and a professor of art at the University of Vermont. She has taught painting at University of Massachusetts–Amherst, Hunter and Yale. She also has a doctorate in aesthetics. She has received grants from the NEA, MacDowell, JFK Center, Virginia Center for the Arts and Getty Foundation. She regularly exhibits in New York, Boston, Los Angeles, Italy and Australia.

katharine montstream

Katharine Montstream is a painter from Burlington, Vermont. She studied painting as a child with private teachers, and is a graduate of the University of Colorado at Boulder. When not painting she can be found spending time with her husband and two children.

ned mueller

Ned Mueller graduated from the Art Center School of Design in Los Angeles. He is a signature member of the Oil Painters of America, the Northwest Watercolor Society, the Plein Air Painters of America and is a Master Pastelist with the Northwest Pastel Society. He teaches workshops, juries shows and has won numerous awards. He currently resides in Renton, Washington.

On the Creek · George Teichmann · Water-soluble oil on canvas · 21" X 20" (53cm X 51cm)

reed prescott III

A graduate of the School of Worcester Art Museum, Reed Prescott's paintings appear in numerous books, magazines and private collections. A winner of two Duck Stamp competitions, he lives in Lincoln, Vermont, with his wife, Lisa, and sons Isaac and Spencer.

george "rinaldino" teichmann

George Teichmann was born in 1957 in the Czech Republic. He graduated from the Peoples School of Art in the city of Beroun. He spent three years at the Bohemian Crystal Glass Cutting School in Podebrady, Czech Republic, from 1975 to 1978. He has had various exhibitions in Eastern Europe. He spent one year at the Paleontological Art School in the Czech Republic before immigrating to Vancouver, British Columbia, Canada, in 1984. He exhibited his work in Canada until moving to the Yukon in 1990. He has since painted paleontological artwork that was exhibited at the Pacific Rim Wildlife Art show in Tacoma, Washington, in 1995.

robert wee

Robert Wee and his wife, Joyce, live in Pollock Pines, California, in the foothills of the Sierras. He is a graduate of the Art Institute of Chicago. He is the father of six adult children. His work is shown in galleries such as the Lee Youngman Gallery in Calistoga, California; the Kerwin Gallery in Burlingame, California; the Poulsen Gallery in Pasadena, California; the Helen Jones Gallery in Sacramento, California; the S.R. Brennen Gallery in Carmel, California; and the Jones Gallery in Escondido, California. Wee is a member of Oil Painters of America.

Hinesburg, Vermont, Dairy Farm · Sean Dye · Water-soluble oil on linen · 16" X 20" (41cm X 51cm) · Collection of the artist

references

Creevy, Bill. THE OIL PAINTING BOOK: MATERIALS AND TECHNIQUES FOR
 TODAY'S ARTIST. New York: Watson-Guptill Publications, Inc., 1994.

Doerner, Max. THE MATERIALS OF THE ARTIST AND THEIR USE IN PAINTING.
 New York: Harvest Books, 1984.

Gettens, Rutherford J. and George L. Stout. PAINTING MATERIALS: A SHORT
 ENCYCLOPEDIA. New York: Dover Inc., 1966.

Gombrich, E.H. THE STORY OF ART. 16th ed. New Jersey: Prentice-Hall,
 Inc., 1995.

Gottsegen, Mark. THE PAINTER'S HANDBOOK. New York: Watson-Guptill
 Publications, Inc., 1993.

Dora Jane and H.W. Janson. THE STORY OF PAINTING. New York: Galahad
 Books, 1977.

Macpherson, Kevin. FILL YOUR OIL PAINTINGS WITH LIGHT AND COLOR.
 Cincinnati: North Light Books, 1996.

Mayer, Ralph. THE ARTIST'S HANDBOOK OF MATERIALS AND TECHNIQUES.
 Cincinnati: North Light Books, 1998.

Mayer, Ralph. A DICTIONARY OF ART TERMS AND TECHNIQUES. New York:
 Barnes and Noble Books, 1981.

Smith, Ray. THE ARTIST'S HANDBOOK. New York: Alfred A. Knopf Inc.,
 1987.

Tate, Elizabeth. THE NORTH LIGHT ILLUSTRATED BOOK OF PAINTING
 TECHNIQUES. Cincinnati: North Light Books., 1996.

index

explore oil painting with
NORTH LIGHT BOOKS

Master painter Kevin Macpherson shares his techniques for capturing the mood of a scene in bold, direct brushstrokes. His step-by-step instructions make it easy—simply a matter of painting what you see. In no time at all you'll be creating glorious oil landscapes and still lifes that glow with light and color.

1-58180-053-3, PAPERBACK, 144 PAGES

Frank LaLumia shows you how to envision nature's essence and capture it on paper and canvas. You'll learn the basics of rendering natural light and color properly, how different paints can affect your plans and how fluency in the language of painting allows you to capture the extraordinary, magical happenings in the world beyond your window.

0-89134-974-X, HARDCOVER, 128 PAGES

Artist Rosalind Cuthbert provides you with visual guidance to over 600 color mixes in oil! You'll find pages of easy-to-follow charts, special mixtures for fleshtones, advice on achieving brilliant colors, transparent overlay effects and technical information on pigments.

0-89134-543-4, HARDCOVER, 64 PAGES